SUMI-E

Just for You

Traditional "One Brush" Ink Painting

HAKUHO HIRAYAMA

KODANSHA INTERNATIONAL

Tokyo • New York • London

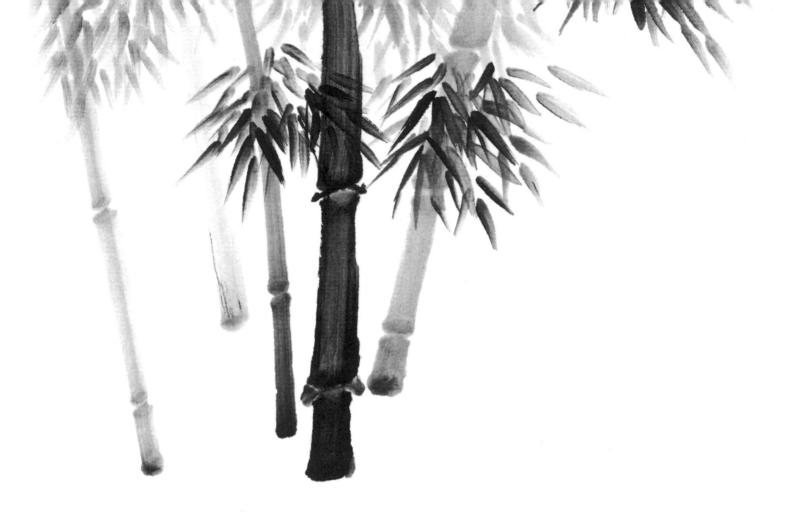

Distributed in the United States by Kodansha America, Inc., 575 Lexington Avenue, New York, N.Y. 10022, and in the United Kingdom and continental Europe by Kodansha Europe Ltd., 95 Aldwych, London WC2B 4JF.

Published by Kodansha International Ltd., 17-14 Otowa 1-chome, Bunkyo-ku, Tokyo 112-8652, and Kodansha America, Inc. Copyright © 1979 by Kodansha International Ltd. All rights reserved. Printed in Japan.

LCC 79-84653
ISBN 0-87011-369-0
ISBN 4-7700-0704-3 (in Japan)

First edition, 1979
01 20 19

CONTENTS

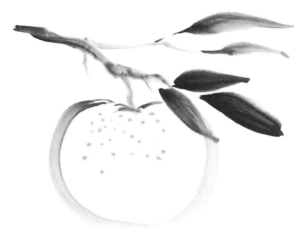

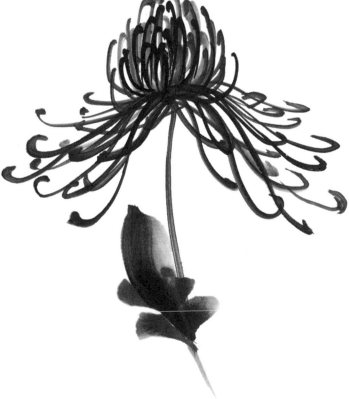

INTRODUCTION

What is sumi-e?

The Japanese word *sumi-e* is made up of the words for "black ink" (*sumi*) and "picture" (*e*). What is called sumi-e, then, is the Oriental art form in which pictures are painted with black ink. But does this mean that any such picture can be called sumi-e? No. To be sumi-e, a black-ink painting must be like a thing alive with the power to stir the hearts and emotions of all who see it.

For the painting to live, every line and even every dot within it must live. And the lines that are said to live in sumi-e are the lines that remain after everything unnecessary to the subject has been excluded from its portrayal. Sumi-e, in other words, communicates the essence of nature. Knowing how to paint and so remove from your subject everything but its life and essence is perhaps the most important thing for you to learn. The real meaning of sumi-e can be found in this, which is beauty condensed and distilled.

Here, too, is found the spirit of Zen. Sumi-e was brought to Japan by Zen priests, and it is easy to understand its appeal to them. For in sumi-e, as in Zen, nothing is wasted and the world is expressed in a language reduced to the farthest, most essential limits. In Zen, what expresses reality may be a single word after hours of silent meditation. In sumi-e, it is a few bold lines on a pure white paper.

Let us see what happens when you paint a sumi-e bamboo tree. First, you face the blank paper before you. You sit up straight and stare deeply into the paper's white surface. One by one, the thoughts that normally occupy your mind grow still and disappear. For you, there is nothing but the paper. And then there appears somewhere within you a trunk, and branches, and you hear the sound of thin, delicate leaves as they stir gently in the wind. You take up your brush and let your hand move naturally, unconsciously, as you paint. Gradually you find the same bamboo you saw in your mind's eye fill out and take shape on the paper before you. Here is a painting that truly lives.

It is in this way—you assume a spiritual posture and stir it into being with well-practiced natural technique—that you can paint

pictures and reach deeply into the hearts of others. If your painting seems somehow harsh or ineffective, you need only the wish to make it more beautiful to get better results the next time you paint. But, a warning—if you practice with the idea "*I want to become good at sumi-e*," then you will probably not improve very much at all. Just thinking in terms of good or bad is a sure sign that you are already far away from the spirit of sumi-e which, like Zen, says, "Become as nothing!" When practicing with this book, free your mind of ambition and desire. If you do this, your paintings will sparkle with life and will draw other people in to feel deeply the many moods of nature.

This book introduces you to "one brush" sumi-e, the art's most traditional and, for many, most appealing form. It assumes no prior knowledge. For that reason, in section I it tells you about all the materials you will need and in section II presents its first four subjects—the bamboo, chrysanthemum, plum, and Chinese orchid —step by step in as much detail as possible. Here there are line drawings and sequence photographs of basic techniques to make the how and why of every stroke easy to learn.

In the next two sections you combine the basic techniques and learn new ones as you practice many different subjects—flowers, trees, rocks, cliffs, mountains, water, and landscapes. In section V are many sample paintings for you to practice.

At the very end of the book are suggestions for practical ways you can use the various sumi-e techniques you have learned. For example, you can apply sumi-e to shirts and other apparel to make unusual gifts for your family. A scarf that you have painted by hand can make a plain ensemble fashionably unique. In other words, with a little imagination you can find many contemporary uses of sumi-e to give pleasure to your family and friends.

When you travel, take a pencil and paper with you so that you can immediately draw the things around you that touch you deeply. Save these sketches and use them later as models for your sumi-e. Even if you are away from home and have no drawing materials, the skills you learn in this book will enable you to look at nature closely and paint what you see on the "surface of your heart," just as if you were actually holding a brush in your hand. You will be surprised at how easily you will later be able to transfer these unwritten impressions to paper.

Before you know it you will find yourself wanting, and able, to paint everything you see. Then look closely at yourself and discover how your back has straightened and how your health has improved. These are the signs that will tell you you have become a real sumi-e artist. Sumi-e, as you can see, is something that can produce much more than paintings.

It is my hope that this book will give you a good start and that the wonderful art of sumi-e will give you great pleasure and satisfaction in the years to come.

—*Hakuho Hirayama*

SECTION
I

A brief look through this first section will tell you two things about sumi-e—that it requires only a few inexpensive materials and that it is among the most uncomplicated of all arts to prepare for and perform. Are these the qualities that are responsible for sumi-e's centuries-old appeal? Probably not, although they do make sumi-e more approachable than many arts in today's busy world. The traditional appeal of sumi-e perhaps lies more in the unique way it coordinates the visible world outside and the felt world within the artist. Working only with a single color, a single brush, and single strokes, the sumi-e artist is incapable of painting the world as it actually appears to the eye. In a sumi-e portrayal of a pine tree, for example, a few dots hint at the cones, the needles may look like the scratch marks of a cat's claw, black-and-white tones replace natural colors. None of these elements really "exists" in nature. Yet, and this is important, we do not feel that the painting is at all abstract. We feel instead that the artist has painted only as much as was necessary to give the tree a recognizable form and then "filled out" this form with feelings and moods to give it life and, above all, familiarity. For all it lacks in precise detail, then, this painting probably tells us what the artist saw and felt more accurately and with more force than any photograph ever could. Sumi-e is among the most honest of arts.

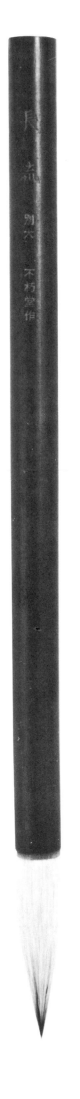

MATERIALS

The materials you will need for sumi-e can be purchased at most stores specializing in Oriental goods. Prices will vary, of course, depending on the store and the quality of the item. Do not feel that you must buy only the best; durable, simple equipment designed for students will serve just as well. See page 96 for places from which sumi-e supplies can be mail-ordered. Complete sumi-e kits are also available, as are special boxes designed for storing sumi-e materials.

Brush

There are many kinds of sumi-e brushes (called *fude* in Japanese). You will need just one brush when working with this book. Its bristles, whether made from deer, goat, or boar hair, should be about $1\frac{5}{8}$ inches long with a diameter of about $\frac{3}{8}$ inch (or about 40 mm by 10 mm). New brushes often contain starch in their bristles to stiffen and protect them during shipment. Soften the brush by pressing it repeatedly with light pressure onto a small water-filled plate until the starch runs off. After use, rinse the brush thoroughly with tap water.

Suzuri

Suzuri (inkstones) are carved from stone and have a well to hold water and a flat surface on which the *sumi* (ink) stick is ground or rubbed to produce ink. Suzuri come in many different shapes and sizes; some old ones are now expensive collector's items. After use, clean the suzuri thoroughly with tap water. Old, dried sumi on the suzuri is very hard to remove and will interfere with the even rubbing of the sumi stick.

Sumi stick

Sumi sticks are made from powdered carbon of burnt pine or lamp black, plus a binding agent. When a sumi stick is rubbed back and forth with a small amount of water on the level surface of the suzuri, small carbon particles come off the stick and dissolve in the water to produce ink. Four different "black" shades are sold: black-black and black-brown (these are used for winter or rocky, mountainous scenes) and black-blue and black-purple (for gentle springtime scenes). You can use any one of these shades, but the black-blue sumi will probably show your work off best in the beginning. The sumi stick requires no special care after use.

Paper and cloth

Sumi-e is best done on unsized paper that will absorb moisture from the wet brush as you paint. Any kind of paper with this characteristic will do, and even ordinary newspaper can be used for practicing. Flat sheets of *gasenshi* (often called "rice paper" in the West but actually made from plant fibers) are particularly well suited for sumi-e. *Gasenshi* can be purchased at the store where you buy your other materials.

A cloth, preferably a piece of felt, may be placed under the paper to absorb excess moisture.

Sumi-e paper is very delicate and should be stored flat in its wrapper. Paper in rolls is sometimes available, but you may need to use a weight with it to prevent it from curling while you work.

Small dish and bowl

You will need a small dish in which to make medium-color ink. A small double-welled bowl filled with water can be used to wash and moisten your brush.

PREPARATION

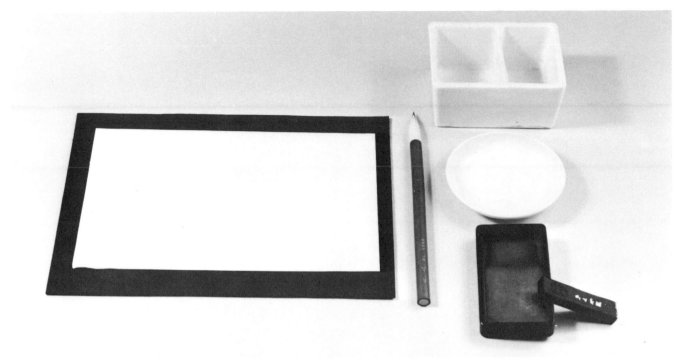

Lay out the sumi-e materials on a desk or table as shown in the photograph. Pour clean water into the well of the suzuri and into the small bowl until they are each about three-quarters full.

Making ink

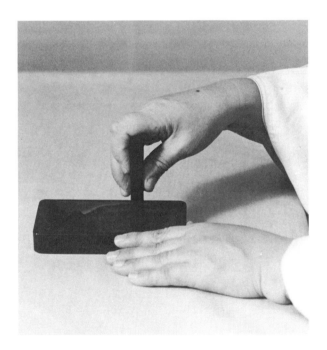

Holding the sumi stick as shown in the photograph, dip its lower end into the well of the suzuri and draw some of the water up onto the suzuri's level surface. Carefully and with even strokes—but without too much pressure—rub the sumi stick over this surface, back and forth. Keep the sumi stick perpendicular; rubbing at an angle will cause carbon particles to come off the stick unevenly and will result in poor ink.

Five to ten seconds of even rubbing should give you good sumi. You will be applying sumi to your brush directly from the suzuri's level surface; when the sumi there has been used up, just repeat the above process to make more.

The depth of color of the prepared sumi is a result of the amount of water you use and the length of time that you rub the sumi stick on the level surface of the suzuri. As you gain experience, your own judgment will tell you the combination of these that you need. It will differ according to the object you are painting and the effect you want to create.

You will often need sumi of medium color to paint light lines or to charge the brush with different sumi shades (explained below). To make medium-color sumi, use the tip of your brush to transfer a small amount of dark sumi from the suzuri's level surface to the small dish; then dilute this ink with a few drops of water from your brush and mix until the desired color is obtained.

Applying sumi to the brush

Never apply sumi to a dry brush. Dip the brush in water and gently swab its bristles against the edge of the bowl to prevent dripping. If you need to use only the tip of the brush to paint a fine line, remove more water from the brush. This will make the bristles firmer, giving better support and control as you paint.

You may charge the brush with dark sumi only, with medium-color sumi only, or with a combination of the two. It is this last especially that makes sumi-e more than simple line-drawing. When a brush is charged with two tones of ink plus water, the ink tones and water overlap and blend together on the paper to give the painted line the appearance of depth. Western artists add depth using fine shading techniques; but the sumi-e artist can get the same effect with a single stroke of the brush.

To prepare this "three-shaded" brush (water can be thought of as one shade), draw the wet brush through the medium-color sumi you have prepared in the small dish; let the medium-color sumi evenly saturate two-thirds of the brush from the tip up. Then draw the brush through the dark sumi on the level surface of the suzuri, but this time let the sumi saturate only the lower third of the bristles. The result will be a brush charged, from the tip up, with one-third dark sumi, one-third medium-color sumi, and one-third water.

When painting a thin line, you can saturate less of the brush with sumi; but the medium and dark shades of sumi on the brush should always be kept in the ratio of two to one. When using a dark or medium shade alone, apply only as much sumi to the brush as you need.

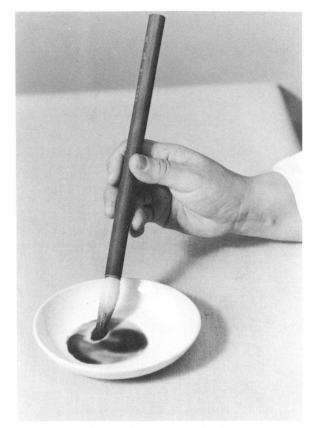

Applying medium-color sumi to the brush

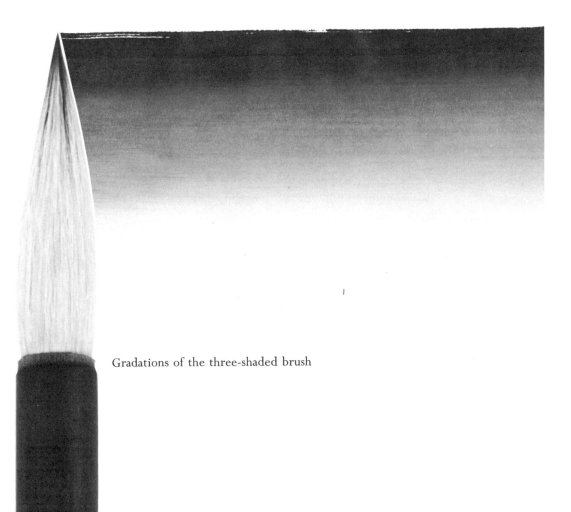

Gradations of the three-shaded brush

HOW TO HOLD THE BRUSH

There are three ways of holding the sumi-e brush. Which method you use will depend on the kind of line you need. Hold the brush firmly enough to control it; but too strong a grip will create tension that inhibits free motion. Different kinds of strokes made using these brush positions will be presented in section II of this book. Other strokes using combinations of these brush positions will be taken up in section III.

METHOD 1: Upright brush—for straight and strong lines or fine lines

Hold the brush perpendicular to the paper. The width of the line painted is controlled by downward pressure that causes the brush tip to bend and point out from where the base of the brush is in contact with the paper. Heavier pressure will yield a broader line. Vertical pressure reaching the paper through the base of the brush allows the tip to move freely, thus giving interesting shading effects.

METHOD 2: Slanted brush—for heavy or broad lines and for shading large areas

Hold the brush at about a 45° angle to the paper. Pressure on the brush without changing the angle of its handle will result in a broader stroke.

METHOD 3: Horizontal brush—for larger areas than can be painted with the slanted brush

Hold the brush almost parallel to the paper. Held palm up, a three-shaded horizontal brush will paint boldest on the "left" side; held palm down, it will paint boldest on the "right" side.

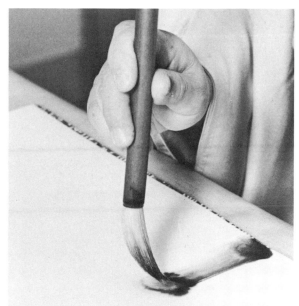

METHOD 1

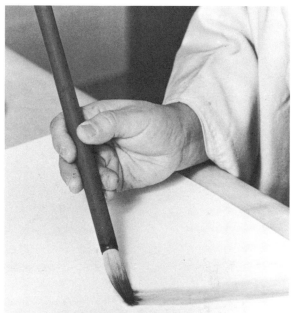

METHOD 2

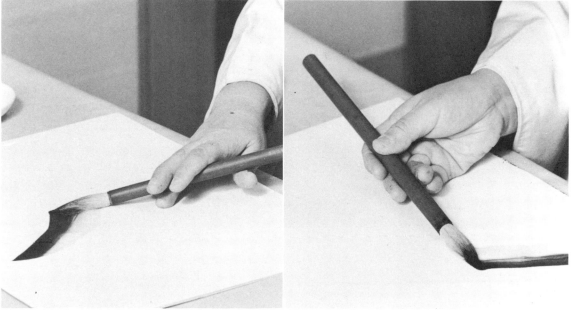

METHOD 3 palm down palm up

MOVING THE BRUSH

Body motion is important in sumi-e. For most strokes keep your fingers, wrist, elbow, and shoulder steady as you move the brush with the entire trunk of your body from the base of your back up. Strokes, even short ones, made with natural body movements will in turn look more natural. Some strokes do involve use of the wrist or elbow together with body motion. These will be explained in the text. Whatever kind of stroke you use, maintain good body posture at all times. Stand at a table or select a chair that permits you to move freely in all directions.

The stroke explanations in the text of this book describe the motions made by a right-handed sumi-e artist. If you are left-handed you should have no trouble with these techniques, though you may find some of them easier if you reverse brush angles or change the order in which some of the picture elements are painted.

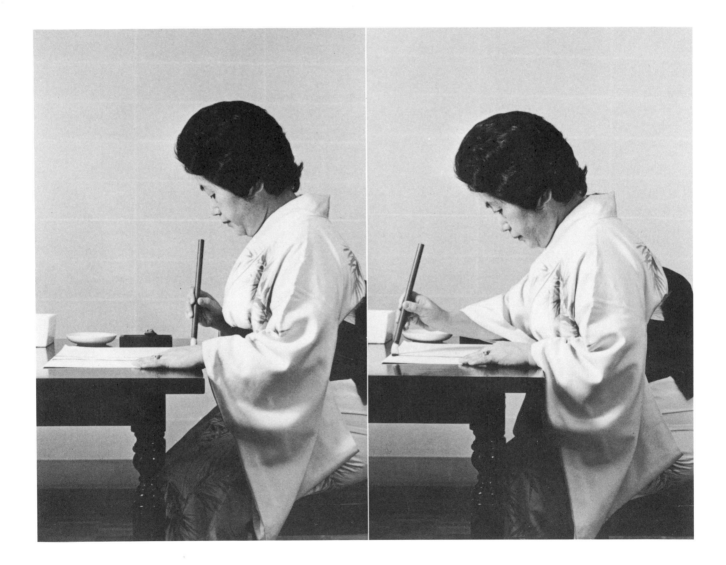

SECTION

II

In this section you will be introduced to the shikunshi, the "four honorable gentlemen" of sumi-e. These are the four seasonal objects from nature—the bamboo (summer), the chrysanthemum (fall), the plum blossom (winter), and the Chinese orchid (spring)—that have traditionally been used in Japan to teach the basic techniques of sumi-e to beginners. The explanations for these paintings have been designed to be as straightforward and practical as possible. This might lead you to believe that "basic techniques" refers only to brush and stroke skills. It does not. The term has a much wider meaning and refers as well to your developing a feel for composition, for mood, and for your materials and the many ways they can be used. Because each of the four subjects in this section expresses a different season, each can be thought of as having a different character. Try to feel the season as you paint. How heavy is the air? What sounds penetrate the night? Be forceful with summer's bamboo, for example, but be delicate and sparing with spring's Chinese orchid. If you paint regularly you will quickly outgrow stroke explanations of the type provided in this book. But the thrill of seeing your work come alive with the emotion you have put into it will remain an ever-fresh experience. It is in anticipation of this thrill, perhaps, that all would-be artists first take up their brushes and begin practice.

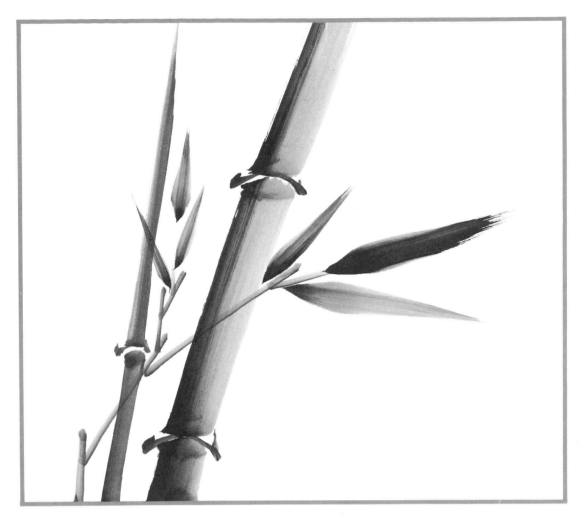

BAMBOO

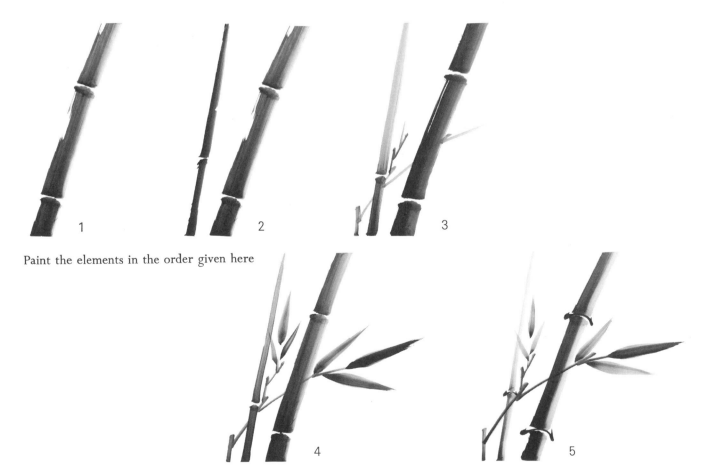

Paint the elements in the order given here

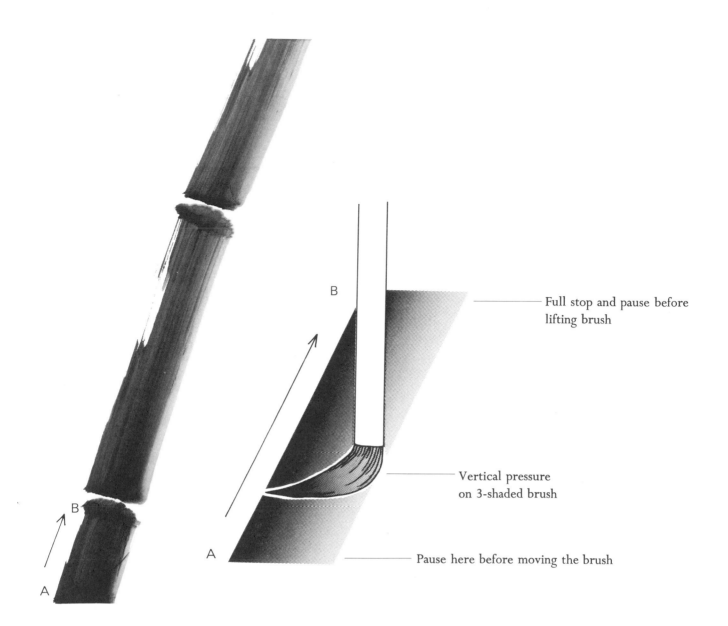

B — Full stop and pause before lifting brush

— Vertical pressure on 3-shaded brush

A — Pause here before moving the brush

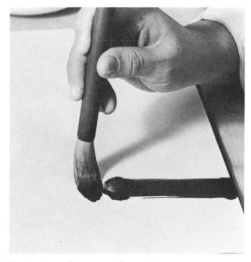

Beginning the second section of the large trunk

Large trunk

Upright brush; 3 shades of sumi. Constant pressure. Pause at the beginning and end of each stroke.

Saturate the brush with three shades of sumi: water at the base, medium-color in the middle, dark at the tip. Hold the brush in upright position (method 1 on page 15). Start at the bottom of the paper (A). Firmly press the brush straight down so that the base of the brush is touching the paper and its tip is pointing out to the left. After a very slight pause, hold your arm steady from hand to shoulder and "push" the brush forward with body motion. Keep the brush at a constant pressure on the paper. When the brush reaches the first joint of the trunk (B), bring it to a full stop. Pause, then lift the brush from the paper. Use a similar technique for the next two trunk sections.

*Make sure vertical pressure remains constant at the base of the brush. This will cause the brush tip, where there is no direct pressure, to trace a rough line at the edge or even break contact with the paper completely.

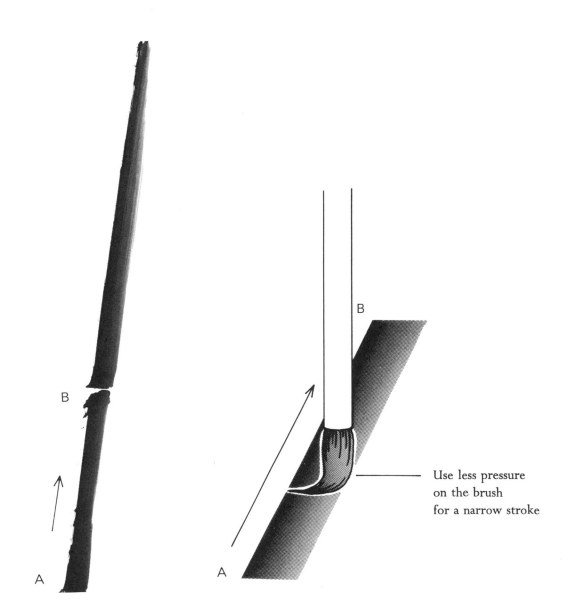

B

Use less pressure
on the brush
for a narrow stroke

A

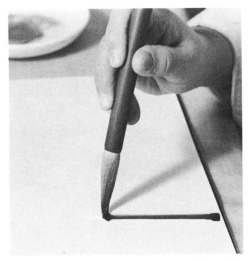

Ending the first section of the small trunk

Small trunk

Upright; 3 shades. Constant pressure. Pause at the beginning and end of each stroke.

Use the same technique here as for the large trunk. But paint only two sections, lighter in color than the large trunk and not quite parallel to it.

*Consider the different variables involved in painting the small trunk: (1) *The amount of water:* Before applying sumi to the brush, remove excess water from its base by swabbing the bristles against the edge of the bowl—this will give the brush more body and make it easier for you to paint the thinner line you need here. (2) *The amount of ink:* Since this trunk is thinner, saturate less of the brush with sumi; but keep the medium and dark shades in the ratio of two to one. (3) *The amount of pressure:* Use less pressure than you did for the large trunk so that less of the brush contacts the paper. (4) *The shadings of sumi:* Use lighter shadings of dark and medium-color sumi; aim for balance of tone with the large trunk. With practice you will be able to bring these four elements together to get just the effect you want.

Small branches

Upright; 3 shades. Zigzag motion until the final branches thin and fade away.

Prepare sumi shades that will complement the two trunks. Use only a small amount of pressure to keep the line thin. Move your entire body in a zigzag motion so that, as shown in the illustration, the brush goes from A to B, returns along the same line to C, angles up to D, and so on, to H on the right of the main trunk. Then place the brush at I and move in similar zigzag fashion until you reach N. The tip of the brush will trail behind as you paint upward.

 *Each group of branches should be painted in a continuous motion. Do not pause at the tip of a branch, and make sure that the brush, when moving ''backward'' along the zigzag, goes down the same line it came up. Gradually decrease the pressure on the brush as you approach H and N. Continue moving the brush even after it has left the paper so that these final branches thin and fade away.

Leaves

Upright; 3 shades. Apply pressure → reduce pressure to tip. Then ''follow through.''

From A paint a short, thin line; then add pressure to attain the width of the leaf (B). The tip of the brush should trail behind the base. As you continue, lift the brush so that less and less of its base is in contact with the paper; this causes the leaf to narrow (C). When you reach the end of the leaf, only the tip of the brush with dark sumi should be in contact with the paper (D). Paint six leaves.

 *To get the leaf to come to a fine point, ''follow through'' on your body motion about four to five leaf lengths after your brush has left the paper.

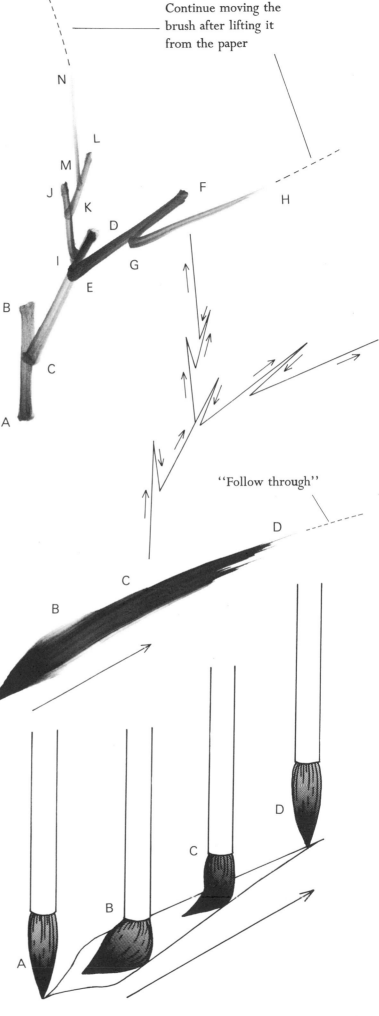

Continue moving the brush after lifting it from the paper

''Follow through''

21

Joints

Upright; dark sumi. Tips will meet the trunk at a fine angle if extended upward.

Use dark sumi only, applied at the very tip of the brush. Paint the joint in one continuous motion without pause. Use body motion.

 *Notice that the curve of the joint complements the top of the section of bamboo below it. The tips of the joint (**A**, **B**) should meet the trunk at a fine angle if extended upward. To get the right shape, move the brush along these angles (the dotted lines in the illustration) both before you touch the brush to the paper at **A** and after you have finished painting at **B**.

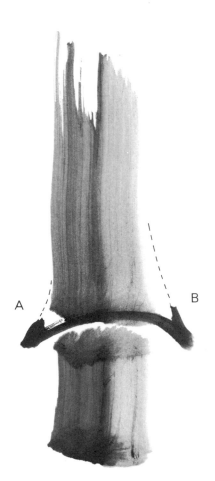

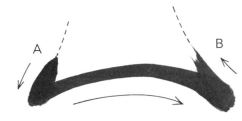

Reminders

1. Keep the brush upright as you paint.
2. Control the brush with the motion of your body from your lower back up.
3. Try to select sumi shades that complement each other. You will have to be the judge of what works best.
4. "Follow through" for pointed lines even after lifting the brush from the paper.

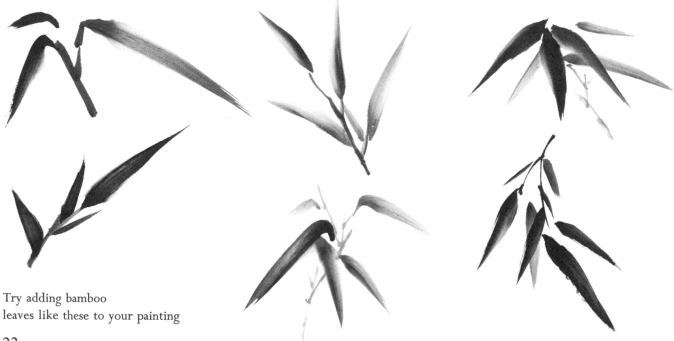

Try adding bamboo
leaves like these to your painting

22

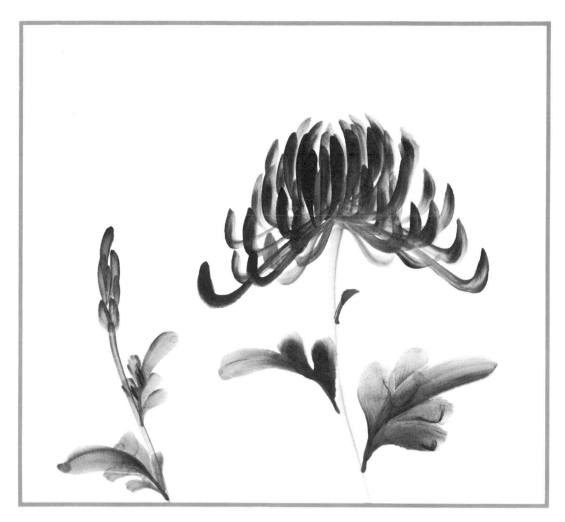

CHRYSANTHEMUM

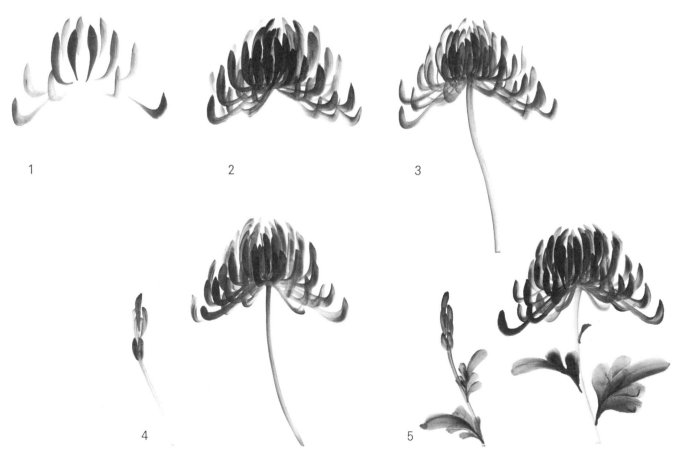

1

2

3

4

5

Petals

Upright; 3 shades. Reduce pressure. Each petal points to the center of the flower.

Use a technique similar to that for the bamboo leaves. Start with pressure on the brush at the top of the petal and lift the brush gradually as you paint toward the center of the flower (**X**). Overlay three or four clusters like the one shown below, refilling your brush each time. Always paint the first stroke near the inside of the flower, where the petals are denser, and work toward the outside as the sumi gets lighter.

*The inside tip of each petal points toward **X** at the center, and the "vertical" parts of the petals grow shorter toward the rim of the flower. A line drawn about the outside of the flower should be in the shape of a mushroom cap, not circular or heart shaped. To give depth to the flower, use different grades of dark and medium-color sumi each time you paint a cluster of petals.

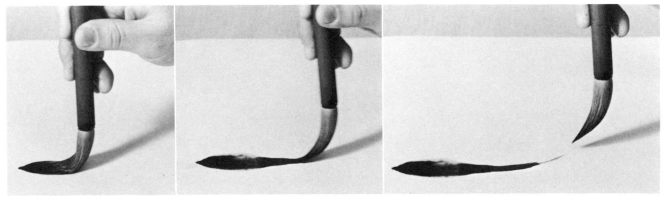

Remove pressure on the brush as you paint toward the center of the flower

RIGHT WRONG

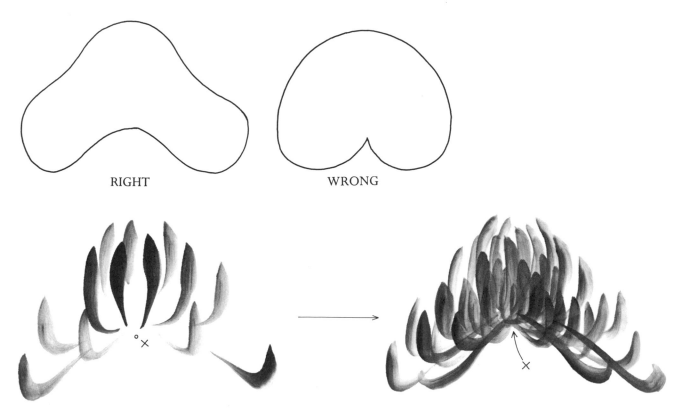

Add petal clusters until the flower takes shape

24

Stem

Upright; dark sumi and water. Start in the center of the flower with "side pressure."

Apply dark sumi to the brush; then dip it in water to make the color less prominent. Hold the brush over the center of the flower; press down on **X** so that the brush tip bends to the left as it contacts the paper. Remove pressure and, using body motion, draw the brush down to the bottom of the paper. Give the stem a natural curve.

 *Applying pressure to the brush before moving it downward will "join" the stem and fill out the base of the flower to which the petals are attached.

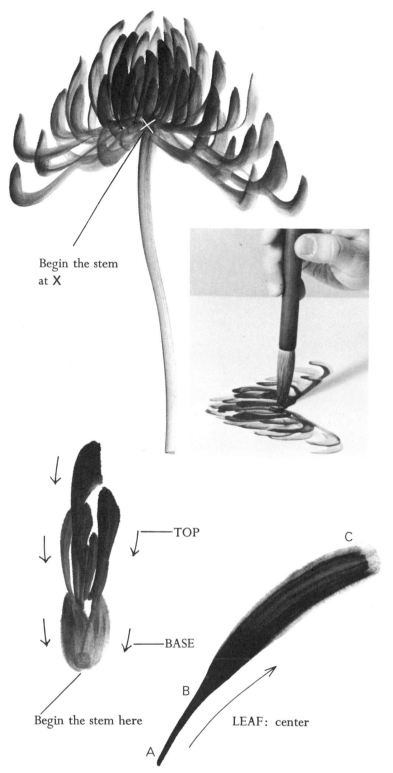

Begin the stem at **X**

Bud

TOP: Upright; 3 shades. Interlocking vertical strokes.

Since the bud is thin, saturate only the first third of the brush with three shades of sumi. The parts of the bud are drawn with the same stroke as the petals. They, too, move toward an imaginary point at the bottom, but "interlock" and remain vertical.

BASE: Upright; 3 shades. Two strokes that intersect to form a V.

Draw two strokes from the top down that intersect to form a **V**. Start with the tip of the brush, apply pressure, then end the stroke with the tip of the brush (see photos and text under "Leaves," below). Draw the stem as you did for the flower.

Begin the stem here

LEAF: center

Leaves

CENTER: Upright; 3 shades. Apply pressure. Then lift the brush and pull the tip through to the end of the stroke.

Use only the tip of the brush (dark sumi) as far as **B** to indicate the stem, then gradually add pressure as you draw the brush to **C**, where the base of the brush should be in full contact with the paper. To prevent the leaf from having a ragged end, lift the brush so that the tip leaves the paper at the farthest point of the leaf (see photos).

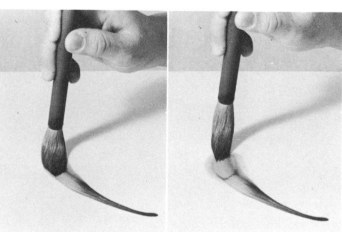

SIDES: Upright; 3 shades. Press the base of the brush down while the tip remains along the midline of the leaf.

Start at **B** with the tip of the brush. Paint away from the midline at a slight angle. Then press down so that the base of the brush reaches out to **D** while the tip remains near the midline. Lift the base of the brush from **D**, move the tip further down the midline of the leaf, and press the base down and out to **E**. Repeat on the other side of the leaf. Paint leaves on the stems of the flowers and buds.

*To draw a leaf viewed from the side, paint the center section and only one side. Leaves will look more natural if drawn at different angles and sometimes with a slight droop. A single petallike leaf drawn near the base of the bud or flower or even an incomplete leaf at the bottom will contribute to the realism of the composition.

C

E

LEAF: side

D

B

A

A FINISHED LEAF

Reminders

1. Keep the brush upright and control it with body motion.
2. When painting leaves and the base of the bud, remove the brush by drawing the tip through to the farthest point painted by the base.
3. "Nature hates uniformity." Your leaves and petals should not all look exactly the same.

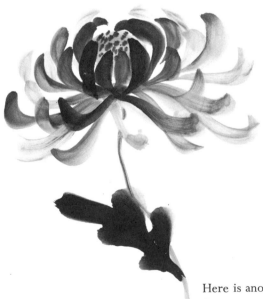

Here is another kind of chrysanthemum for you to practice

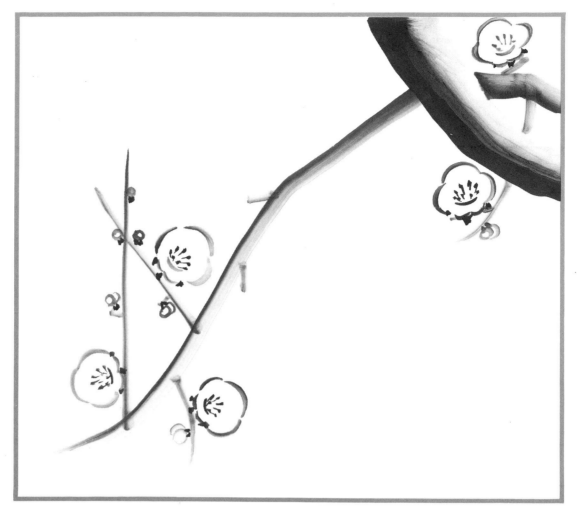

PLUM BLOSSOM

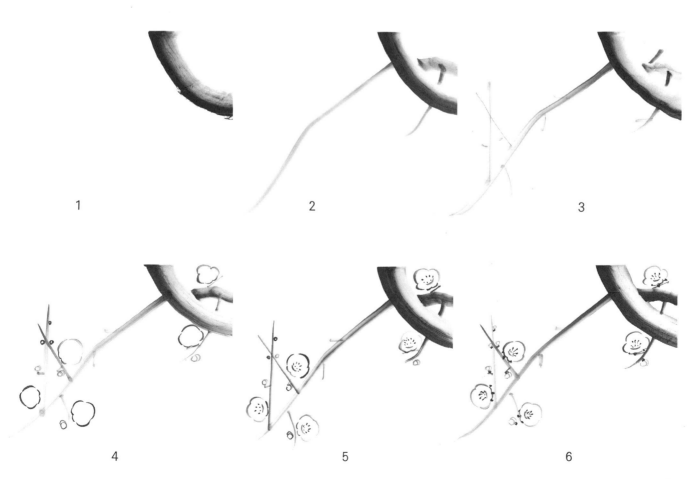

1

2

3

4

5

6

Trunk

Slanted (or horizontal); 3 shades.
Even pressure.

Use a slanted brush (method 2 as described on page 15; the horizontal brush, method 3, may also be used if you want a wider line). Begin at the top, parallel to the edge of the paper. As you paint downward, swing your elbow out on a flat plane to the right so that the trunk bends and runs off the right edge of the paper. Keep the tip of the brush on the lower edge of the trunk.

 *Body motion alone to control the brush here would be too clumsy, so the elbow is used. But keep your hand and wrist steady. The trunk should be drawn in a single smooth motion and with even pressure.

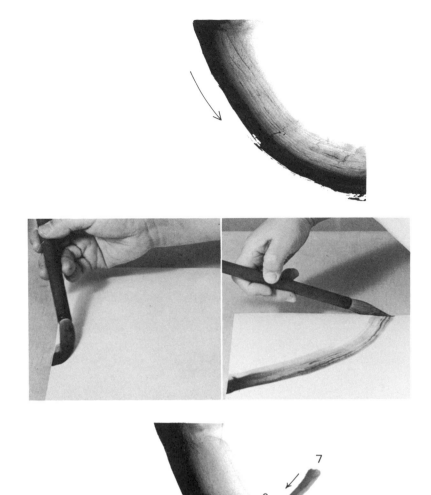

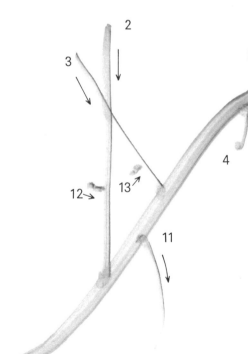

Begin the branches within the trunk

Branches

Upright; 3 shades. Begin or end each branch within another line.

For the long branch, begin with "side pressure" inside the left edge of the trunk to make its attachment look natural.

Draw the two vertical branches from the top down, ending the strokes inside the long branch. To give these branches a point and a natural thickening, start moving the brush along the line of the branch before you touch it to the paper; then apply very slight pressure as you approach the long branch.

Use similar techniques to paint the remaining branches as shown in the illustration.

 *Shading on these branches will not be as distinct as on the trunk. Apply dark sumi to just the tip of the brush. Remove excess water from the base so that the bristles there are rigid and give the brush support while you paint.

Flowers and buds

PETALS: Upright; 3 shades. Thin line → apply pressure → reduce pressure.

Each flower has five rounded petals. Start each petal with the tip of the brush on **A**, apply pressure to **B** so that the line thickens, then reduce pressure until the stroke ends in a thin line at **C**. Paint two short petals at the front of the flower, closer to the branch. Then paint three somewhat longer petals in one continuous, clockwise motion (with varying pressure).

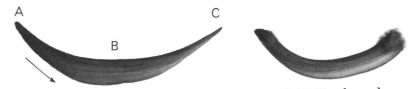

RIGHT

WRONG: the ends are not pointed

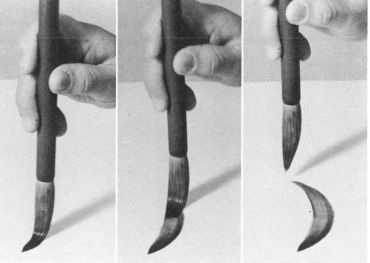

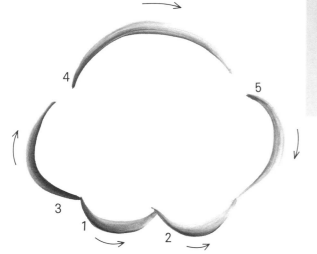

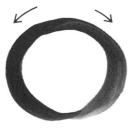

YOUNG BUD

MATURING BUD

BUDS: Upright; 3 shades. Use strokes like those for the petals.

Young buds have two lines that overlap at their ends to form a circle. Maturing buds have a third line to show where the flower has begun to protrude.

FLOWER BODY: Upright; 3 shades. Curved line at the front. Add dots and fine lines in dark sumi.

The curved line inside the front two petals represents the lip of the flower. Show the well of the flower by making several small dots and drawing fine lines from them toward a point just below the center of the curved line.

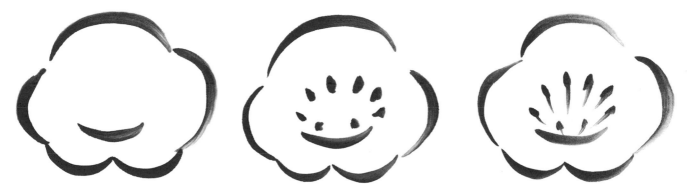

Stems

Upright; dark sumi. Dots at the bases of flowers and buds.

Use only the tip of the brush to add three black dots to the bases of flowers and two black dots to the bases of buds to "connect" them to the branches. Dots on flowers look more natural if arranged not in a neat row but along the tips of the two short curves at the front.

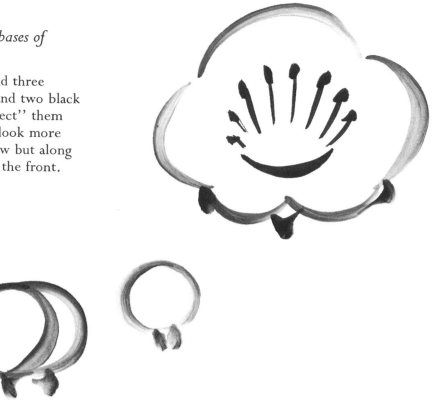

Reminders

1. Use less sumi for the branches than you used for the trunk to make them soft and delicate.
2. For branches beginning in points, begin the drawing motion before touching the brush to the paper.

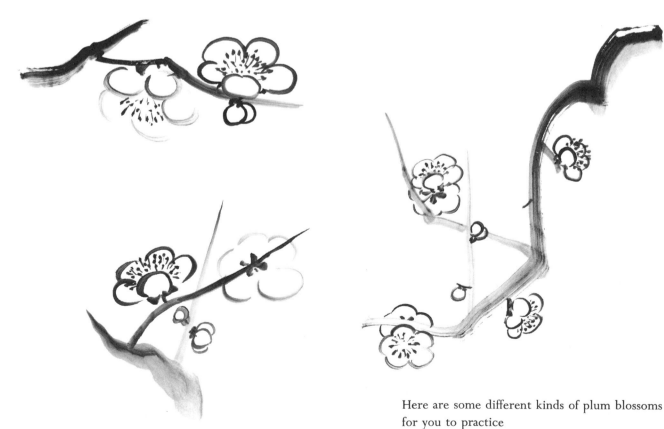

Here are some different kinds of plum blossoms for you to practice

30

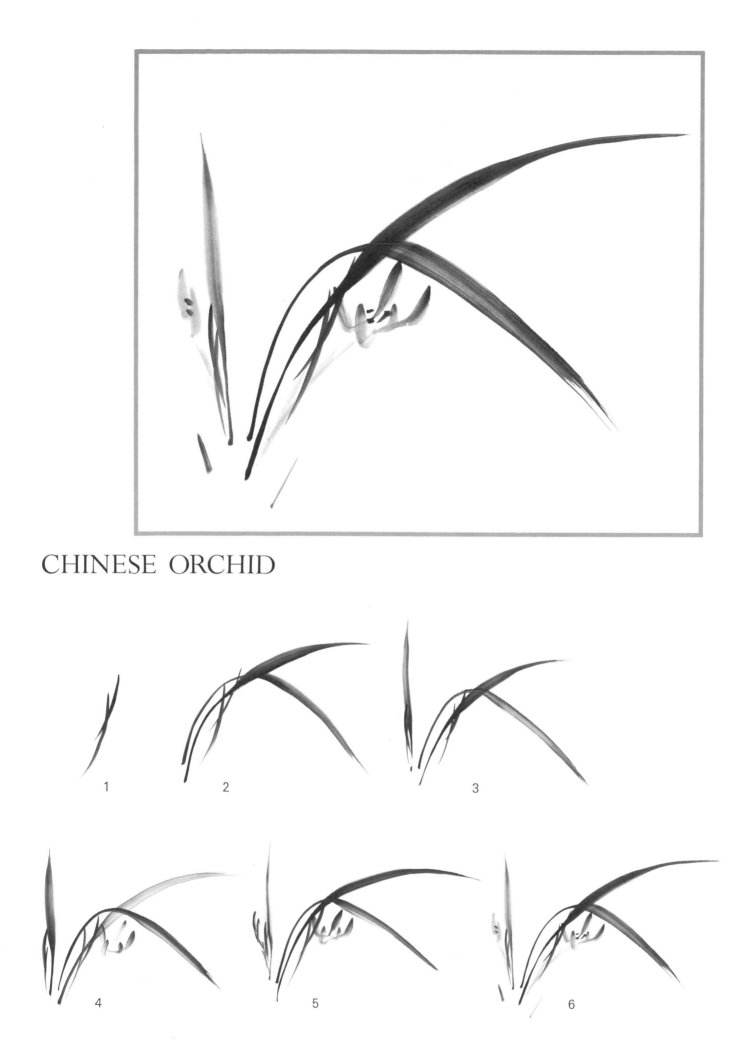

CHINESE ORCHID

1

2

3

4

5

6

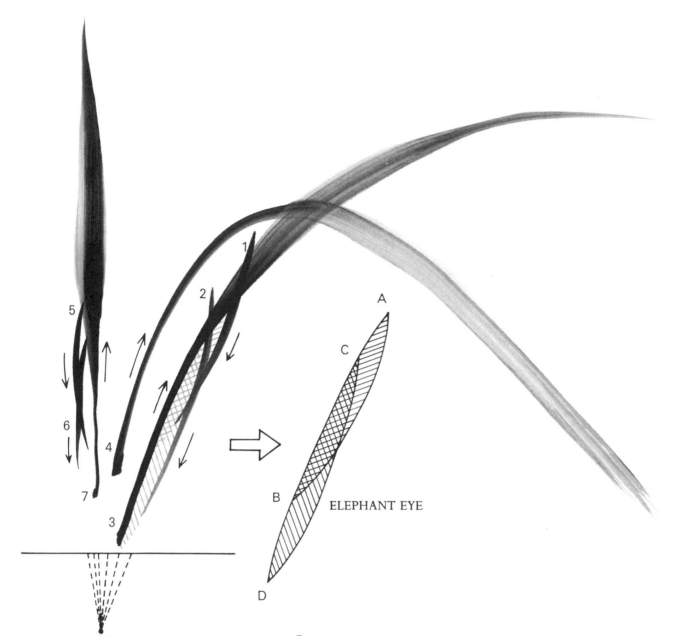

ELEPHANT EYE

Leaves

Upright; 3 shades. Apply pressure → reduce pressure. Use curving strokes that create "elephant eyes."

For each leaf, start with a thin stroke, add pressure, then lift the brush gradually and finish painting the leaf with the tip. Note that stroke 3 (which runs upward to the right) begins at a point which lies along the extension of stroke 2. The order in which the strokes are drawn is traditional and, if followed, will help you paint in fluid motions. All the leaves, if extended at the bottom, should meet at imaginary point X below the earth line.

*Balance in this composition is created by the three leaves painted with ascending strokes. The triangle formed by connecting their tips has unequal sides. Oval spaces created by leaves that intersect (or seem to intersect) twice are called "elephant eyes" in Japanese (in the illustration, the areas between A and B and between C and D); they appear when the leaves you paint are naturally curved and positioned.

Flower, stem, and bud

FLOWER: Upright; 3 shades. Reduce pressure. All strokes meet at X at the center of the flower.

Use the same kind of stroke as for the chrysanthemum petals. Finish each stroke with a thin line, all five petals meeting at X in the center of the flower.

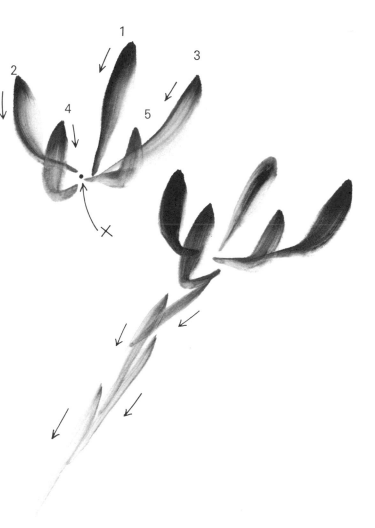

STEM: Upright; 3 shades. Reduce pressure. Overlap the strokes.

Use several lines of the same type as you used for the first and second leaves—draw from the top down and end in a point. But overlap the lines at fine angles so that the stem looks solid.

BUD: Upright; 3 shades. Two overlapping strokes.

Use strokes like the ones for the flower stem but vertical and a bit broader. Then add the stem. Finish the bud by placing two dark dots near the base of the first stroke.

 Place three dark dots in the center of the flower.

 To complete the Chinese orchid, add two more short leaves near the earth line. Make sure these leaves, like the others, angle toward imaginary point X.

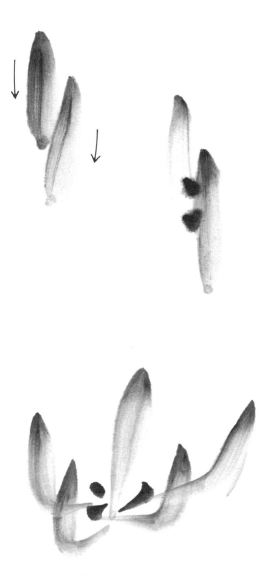

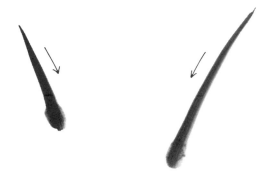

33

Reminders

1. The Chinese orchid is very delicate. Use only slight pressure; let your lines end in fine points.
2. Paint leaves that intersect twice to create "elephant eye" spaces in between.

Here are some other orchid varieties for you to practice

SECTION
III

You will need to learn only about a dozen basic sumi-e strokes to be able to paint what your eyes see and capture the moods and feelings that inspire you. You may be surprised to know that you have already learned most of these strokes in section II. Here in section III you will find new applications for them as well as detailed explanations of the new brush techniques that remain. These new strokes in particular require good brush-and-body coordination. If you have gotten into the habit of using body motion when you paint you should have no trouble learning them. You will surely notice that parts of different subjects may be painted with almost identical techniques. Needless to say, this doesn't mean that these parts should look exactly the same, though it does perhaps suggest the happy conclusion that the world of nature is not as hopelessly diverse as it sometimes seems. Knowing how to use the same technique to achieve different but appropriate results will depend as much on your control of the brush as on your knowing the effect your subject demands. This means you must closely observe nature in all its moods and forms. An eye for the similarities in nature will help you identify which techniques you can use in your paintings; an eye for the differences will help you use these techniques to give shape to your emotions.

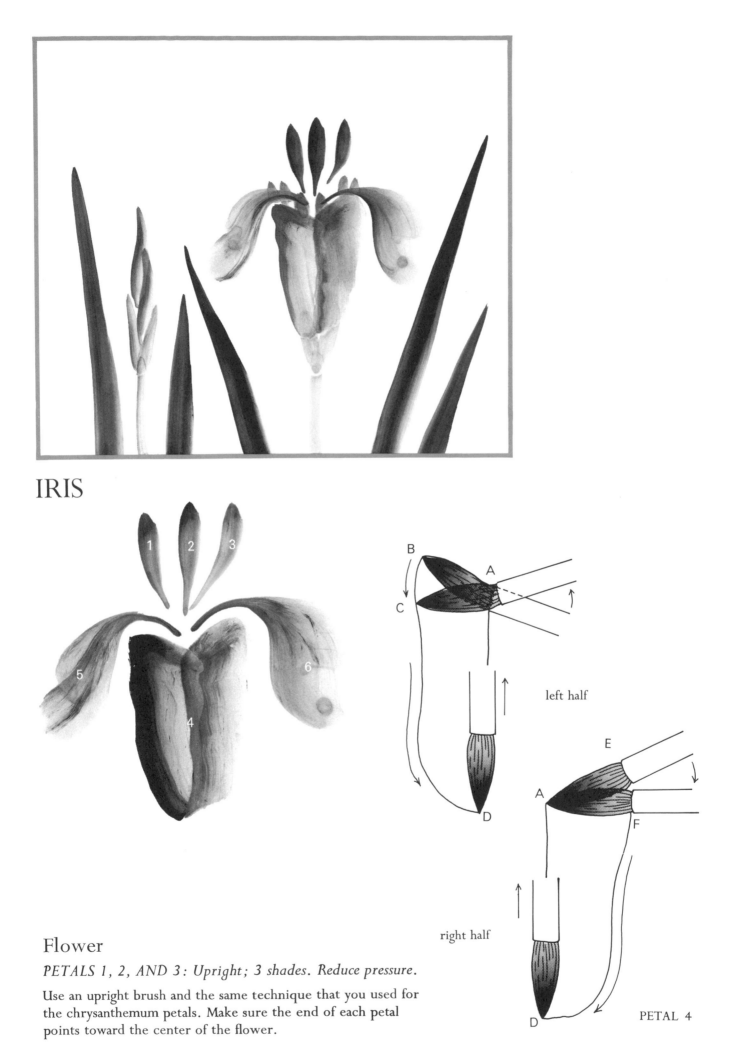

IRIS

left half

right half

PETAL 4

Flower

PETALS 1, 2, AND 3: Upright; 3 shades. Reduce pressure.

Use an upright brush and the same technique that you used for the chrysanthemum petals. Make sure the end of each petal points toward the center of the flower.

PETAL 4: Horizontal → upright; 3 shades. Two strokes. The brush pivots at the top and then becomes upright as it paints down.

For the left half, lay the horizontal brush on the paper with the base on A and the tip on B. Rotate just the tip of the brush from B to C by swinging your elbow up and out to the right. The base of the brush, on A, will start to lift with this motion. Paint down to D and continue to raise your elbow so that the brush becomes more vertical and the stroke narrows. At D the brush will be upright.

For the right half, swing your elbow out and a bit forward to the right of your body before you begin. Lay the horizontal brush on the paper with its base on E and its tip on A. Lower your elbow to move just the base of the brush from E to F; the tip stays on A. Paint down to D as you raise your elbow again to lift the base and narrow the stroke. End at D with the tip of the brush.

*Painting these two strokes slowly will bring out the natural softness of the iris. Use only elbow and body motion as you paint— your hand and wrist should remain fixed relative to the brush. Leave plenty of space between the first three petals and petal 4 for the thin lines that begin petals 5 and 6.

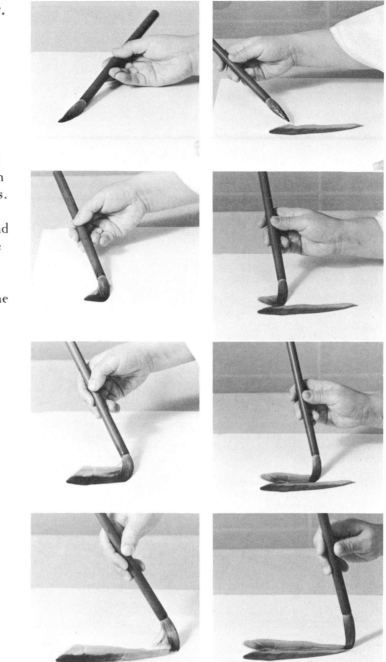

Painting petal 4

PETALS 5 AND 6: Upright; 3 shades. Use the technique of the chrysanthemum leaf.

For each petal, start with a fine line that curves along the top of petal 4. Add pressure as you paint out and down, then remove pressure until the tip of the brush leaves the paper at the edge of the petal. Paint the side part of each petal by pressing the base of the brush outward while the tip remains near the midline.

Finally, use an upright brush and dark sumi to place two vertical dots atop each petal.

PETALS 5 AND 6

Base and stem

BASE: Upright; medium-color sumi and water. Two strokes that form a V.

Use only medium-color sumi. Since the top of the base of the flower should appear to be hidden by the center petal 4, dip the brush in water before painting to further dilute the color of the sumi. Draw two lines that intersect to form a V.

STEM: Upright; medium-color sumi and water. Start in the center of the V.

"Attach" the stem to the center of the V by applying slight downward pressure that bends the tip of the brush to the left. Then reduce the pressure and paint downward.

Bud

Upright; 3 shades. Thin line → apply pressure → reduce pressure. Overlap the strokes.

The two strokes for the bud are drawn like the petals of the plum blossom—thin lines (A) that thicken with pressure (B) and then narrow as pressure is removed (C). But the strokes here are vertical, not curved. Start the second stroke in the center (thickest point) of the first.

 *Together, these two strokes should have the appearance of being twisted together like the strands of a rope.

 Now paint the base and the stem as you did for the flower. The entire base is visible here.

Leaves

Upright; 3 shades. Apply pressure in a quick downward motion.

For each leaf, draw downward at an angle and continue to apply pressure until the brush runs off the paper. Keep the tip of the brush on the edge of the leaf.

 *To get a fine point on the leaf, start moving your body to draw the line before the brush touches the paper. Try to estimate where on the paper each leaf will end before you begin; aim for balance in your composition.

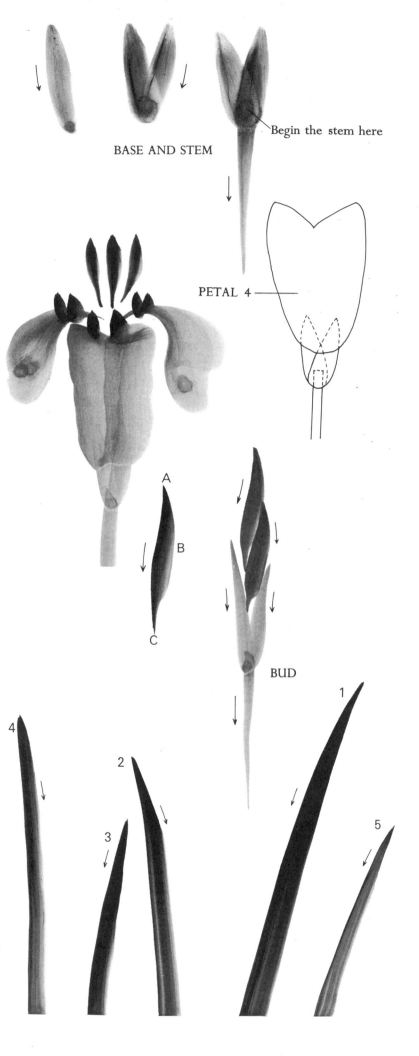

BASE AND STEM

Begin the stem here

PETAL 4

A
B
C

BUD

38

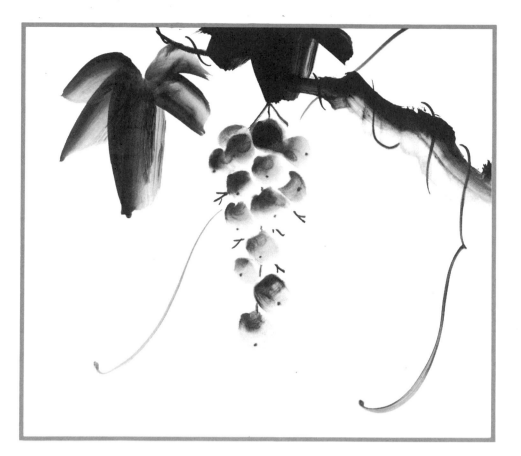

GRAPE VINE

Grape cluster

GRAPE: Upright; 3 shades. Keep the tip stationary as you move the base.

Start in the center of the cluster. Begin each grape with an upright brush at **A**. Let only the tip of the brush touch the paper here. Apply pressure so that the bristles at the base of the brush fall along the line from **A** to **B**. With the tip of the brush still on **A**, paint to **C** and **D**; use your forearm to swirl the brush. Then paint to **E** and back to **A**, reducing pressure on the brush until only the tip remains in contact with the paper.

As the sumi lightens with use, paint partial grapes beside or "behind" whole ones (the light sumi is hidden by the dark to make a partial grape).

The tip of the brush stays on **A**

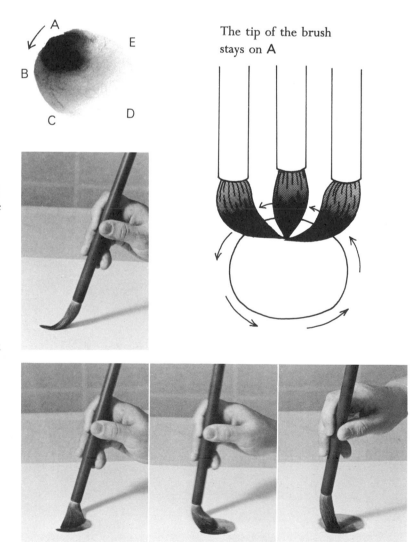

39

STEM: Upright; 3 shades. Paint several sections in one continuous motion.

Use separate lines painted in a continuous motion to ensure that the sections of the main stem line up with each other. Paint the side stems. To show where grapes have fallen off, draw a short stem out from the cluster and bring the brush to a full stop before lifting it, as you did for the bamboo trunk.

The end of the stem holding each grape is made with a dot of dark sumi.

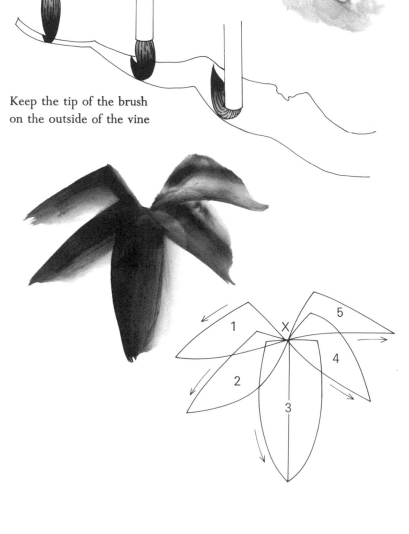

Pause here and change the direction of the stroke

Vine

Upright; 3 shades. Add pressure with start-and-stop motion.

Gradually add pressure as you paint along the top edge of the paper and then down to the right. Keep the tip of the brush on the "outside" of the vine. To show the crooks in the vine, stop the brush briefly at irregular intervals and, without lifting the brush from the paper, continue painting with more pressure and in a slightly different direction.

Keep the tip of the brush on the outside of the vine

Leaves

PARTS 1 AND 2: Horizontal → upright; 3 shades. Raise your elbow to lift the base of the brush as you paint.

Lay the base of the brush near **X** at the top-center and draw the brush to the left, raising your elbow so that the base of the brush gradually lifts and the stroke narrows (as you did for the left half of the center iris petal). Use a similar technique for part 2.

PART 3: Upright; 3 shades. Two overlapping vertical strokes.

Paint two overlapping vertical strokes, left and right, each starting in the center of the leaf at the top.

PARTS 4 AND 5: Horizontal → upright; 3 shades. Raise your elbow to lift the base of the brush as you paint.

Change the orientation of the brush. Its tip should point toward you while the handle slants back toward the top edge of the paper. Paint down and to the right with a stroke like the one you used for the right half of the center iris petal—the tip draws a straight line as the base lifts from the paper. Part 5 is painted like part 4.

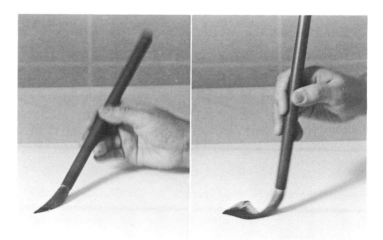

Painting part 1

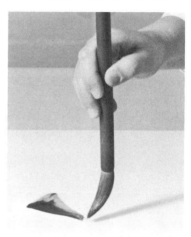

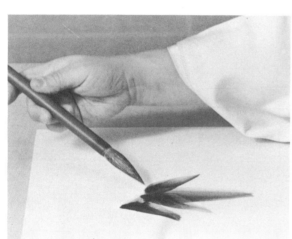

Beginning part 5

Tendrils

Upright; medium-color sumi. No pressure. Paint in a continuous motion.

Paint a thin line that appears to coil around the vine. Then paint tendrils that hang down and curl up at their ends.

　*Use body motion to paint these strokes. Paint quickly and without stopping. The coiling tendrils hug the vine and do not droop.

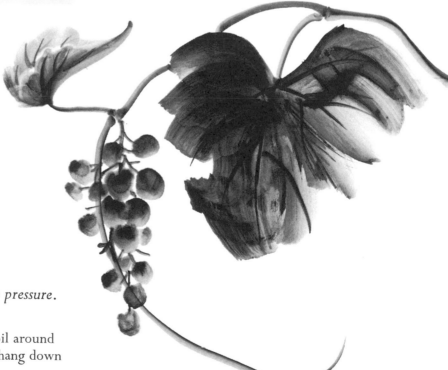

Variation for practice

41

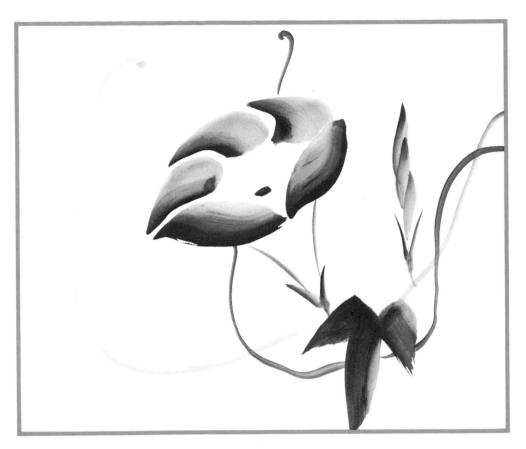

MORNING GLORY

Flower

Slanted; 3 shades. Apply pressure → remove pressure while lifting your elbow.

For petal 1, start with the tip of the slanted brush on **A**; the handle of the brush should be slanting away from you toward the top right edge of the paper (see photo). Apply pressure to thicken the line at **B** while you lift your elbow to draw the brush to the right; the handle circles around in back to the left. The tip of the brush moves along the lower edge of the petal. Start to remove pressure and end the stroke with only the tip of the brush on the paper at **C**. Petal 2 is painted with the same kind of stroke.

*This stroke is painted entirely with elbow motion. Keep your hand and wrist fixed in relation to the brush.

Petals 3, 4, and 5 use a similar technique. But because of their shape and angle, move your elbow down and away from your body as you paint. At the end of the stroke, lift the brush in the direction of the center of the flower. This will help you keep the inside of the flower oval shaped.

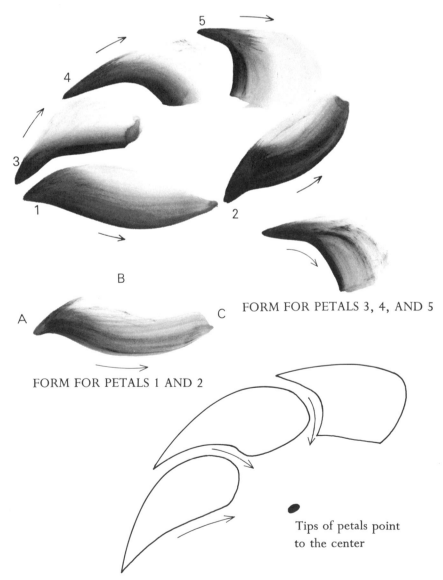

FORM FOR PETALS 3, 4, AND 5

FORM FOR PETALS 1 AND 2

Tips of petals point to the center

Now place a dark, oval dot in the center of the flower.

Body, base, and stem

BODY: Upright; 3 shades. Two flaring lines.

The strokes for the body are painted almost exactly like those for the plum blossom petal. Keep them wide apart and let the top tips flair out so as to support the flower.

BASE AND STEM: Upright; 3 shades. Two lines that form a V and one short line.

The strokes for the base are very pointed at their tips and flair out to enclose the body of the flower. The stem is short and thin; start it within the V of the base.

Bud

Upright; 3 shades. Use "twisted rope" strokes.

Use three vertical "twisted rope" strokes like those you used for the iris bud, but a bit narrower. The base and stem of the bud are like those of the flower.

Vine

Upright; medium-color sumi. Paint in one continuous motion.
Start from the right and let the vine curve around so that the stems of the flower and bud attach to it. Hook the vine at the end with a curve and full stop of the brush to show how the vine grasps objects to secure the plant and pull it upward.

Leaf

SIDES: Horizontal; 3 shades. Lift the base as you paint. CENTER: Upright; 3 shades. Two overlapping vertical strokes.

Paint the leaf just like the grape leaf but with only one stroke on each side instead of two.

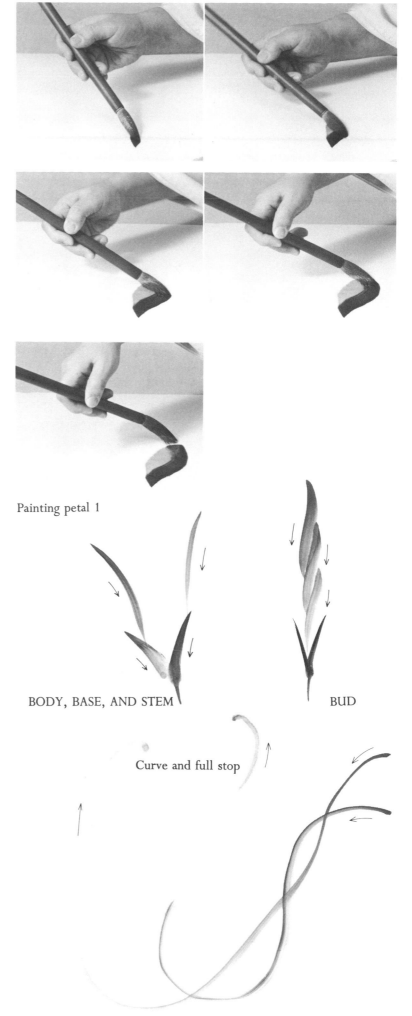

Painting petal 1

BODY, BASE, AND STEM BUD

Curve and full stop

43

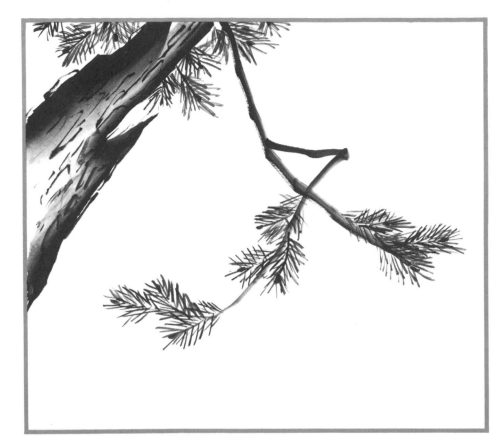

PINE TREE

Trunk

Horizontal; 3 shades. Hold the brush palm down.

Paint the left side of the trunk first. Hold the brush palm down and keep the tip on the outside edge of the trunk. About a third of the way down, push out and slightly up from the line to widen the trunk and give it visual interest. Then continue painting down until the brush runs off the paper.

For the right side of the trunk, hold the brush so that the tip points to the right. About halfway down, form a jagged hook on the trunk by pushing the brush in a curving motion up and out to the right; let the tip of the brush lead the base here. Pull the brush back down the same line it went up and continue painting with a broad shaded line.

*Start the right side of the trunk with the angle of the brush handle at about 45° relative to the trunk line. This will enable you to give the hook halfway down a sharp point. After returning down the line of the hook, swivel your wrist to the right so that the brush handle is perpendicular to the trunk line. This will enable you to paint the broader stroke you need to fill in the center of the trunk.

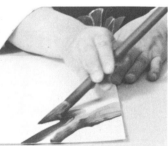

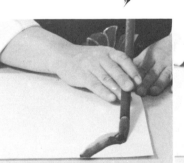

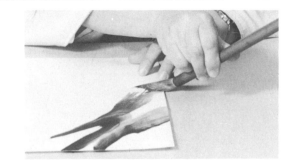

44

Bark

Upright; dark sumi. "Honeycomb" shapes that fatten at the center of the trunk.

Show the coarseness of the pine bark by drawing staggered, rough hexagonal shapes on the surface of the trunk. Use only straight lines and make the angles distinct.

*Paint these shapes thin on the edge of the trunk and fatter toward the center to suggest the tree's curvature. Don't worry if they extend beyond the trunk line.

RIGHT: use only straight lines to paint the bark

WRONG

Branches

Upright; 3 shades. Decreasing pressure with start and stop motion.

Use a technique almost opposite to that used for the grape vine. Start with pressure (inside the trunk line) and gradually reduce the pressure as you paint. Stop the brush abruptly at irregular intervals and change the direction of the stroke.

*To look most natural, the tips of all branches should appear to be reaching upward. Get this effect by bringing the brush to a full stop at the end of the branch; then lift it toward the top left when you remove it from the paper so that the tip of the stroke curls up ever so slightly.

Start from inside the trunk

Pause and change the direction of the brush

Lift the brush in the direction of the arrow

Needle clusters

SHAFT: Upright; 3 shades. Pause at each end.

Give the central shaft blunt ends by pausing with the brush at the beginning and end of the stroke as you did for the bamboo trunk.

NEEDLES: Upright; 3 shades. Zigzag motion.

Use thin, blunt-ended strokes. Move your body along a zigzag and paint from the shaft outward at about a 45° angle. Then draw a second layer of needles on top of the first but at a sharper angle to the shaft.

Place an elongated dark dot at the tip of each needle cluster for the cone.

RIGHT: give the shaft blunt ends

WRONG

FIRST LAYER (45°)

SECOND LAYER AND CONE

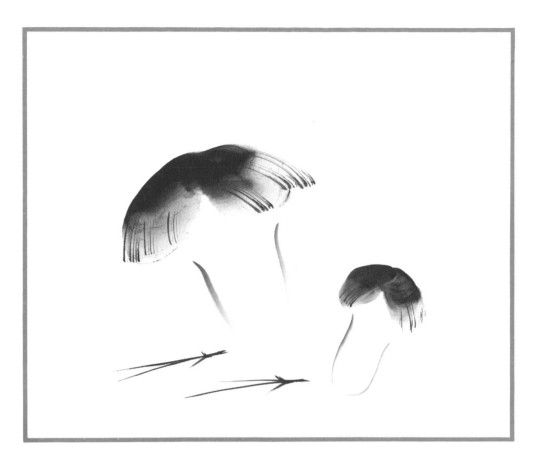

MUSHROOM

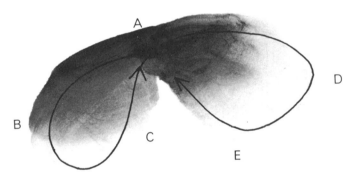

SHADING FOR THE CAP

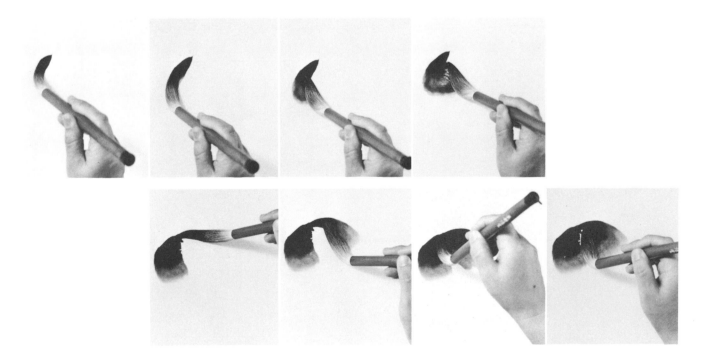

Cap

Upright → slanted → upright; 3 shades. Keep the tip of the brush stationary as you you swirl the base.

Use a stroke similar to that for the grape. Place the tip of the brush on **A**. Press the base down to **B**. Move your elbow to swirl the base around to **C**. At **C**, remove pressure until only the tip is touching the paper at **A**. Now, without removing the brush from the paper, slant the brush until the bristles at the base fall to the right as far as **D**. Bring the base of the now slanted brush around to **E**. Then stand the brush upright on **A** and remove it from the paper.

 Add a few dark lines freely to the cap to bring out its roundness and texture. Let the lines extend beyond the cap to indicate its irregular edge.

Base

Upright; 3 shades. Technique for the plum blossom petal.

Draw two lines whose lower tips angle inward and whose upper tips flair outward to support the cap.

Pine needles

Upright; 3 shades. Pause at the beginning and end of each stroke.

The pine needles accentuate the shape of the mushroom. Begin and end with a full pause to give the ends a blunt appearance. Paint the V-shaped base in just one stroke.

 *Curve the needles slightly. Perfectly straight lines will clash with the roundness of the mushroom.

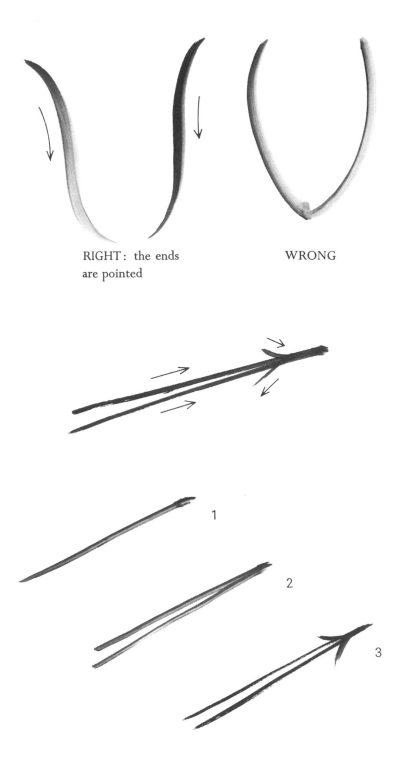

RIGHT: the ends are pointed

WRONG

1

2

3

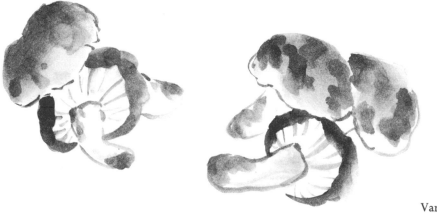

Variation for practice

47

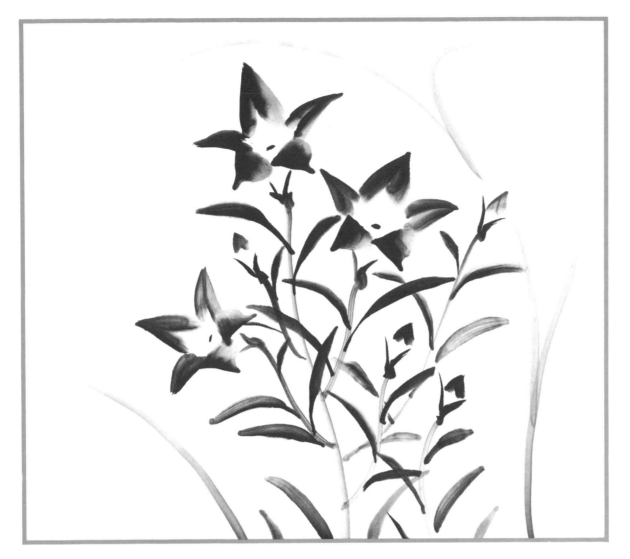

CHINESE BELL FLOWER

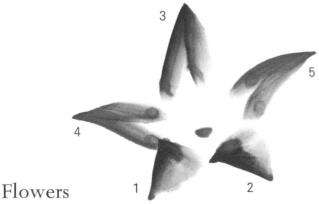

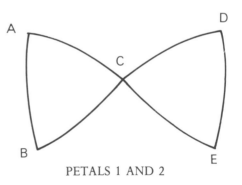

PETALS 1 AND 2

Flowers

PETALS 1 AND 2: Slanted → upright; 3 shades. Lift the base of the brush as you paint and end the stroke with the tip.

For petal 1, start with a slanted brush. Place the tip on **A** and the base on **C**. As you draw the tip straight down, raise your elbow in proportion to the motion of the brush so that the base lifts from the paper and the stroke narrows. By **B** your brush should be upright. Repeat this stroke for petal 2, but this time with the tip at **C** and the base on the outside of the petal at **D**. End the stroke with the tip at **E**.

　*Petals 1 and 2 are triangles with all sides of equal length. Lines **B–C–D** and **A–C–E** are straight lines.

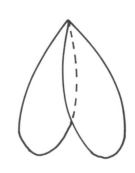

PETAL 3

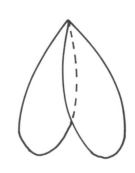48

PETALS 3, 4, AND 5 : Upright; 3 shades. Two overlapping strokes for each petal.

For each half of petal 3, apply pressure as you draw the brush to the center of the flower. Overlap the two halves, leaving just a small notch open at the base of the petal. Petals 4 and 5 are drawn in similar fashion but with slightly curving lines.

Place an oval dot in the center of the flower.

Body, base, and stem

BODY AND BASE: Upright; 3 shades. Two overlapping strokes that form a V.

The body of the flower may be drawn with thin lines or only suggested by leaving a space between the petals and the base. For the base, use strokes like those for the bases of the chrysanthemum bud and iris flower.

STEM: Upright; 3 shades. Start in the center of the V.

Draw the stem with a thin, tapering line.

Buds

Upright; 3 shades. Two overlapping strokes that form an upside-down V.

Paint the bud with the same two strokes you used for petal 3. The base should be at some distance from the bud.

Leaves

Upright; 3 shades. Use the technique for the central part of the chrysanthemum leaf.

Paint slender leaves outward from the stem. Make sure you move the tip of the brush through to the very end of the leaf before lifting it from the paper.

*Leaves should be staggered, not opposed, on the stem.

Grass

Upright; medium-color sumi. Paint from the bottom up in quick motions.

Add wispy meadow grass to the background with quick body motions. The strokes here are like those for the Chinese orchid leaves but much more delicate.

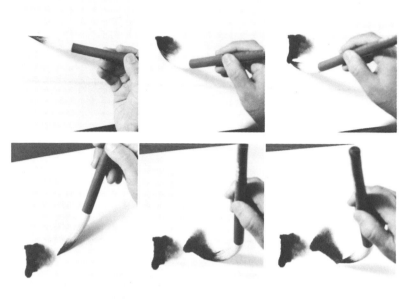

Painting petals 1 and 2

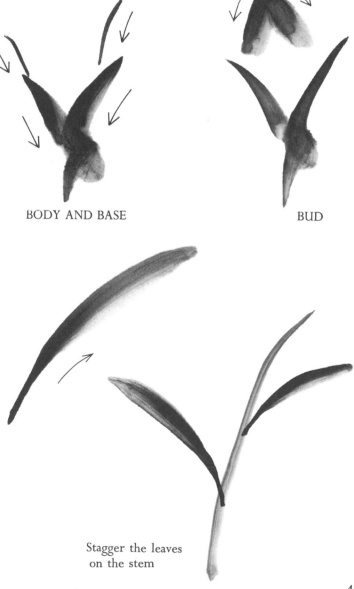

BODY AND BASE BUD

Stagger the leaves
on the stem

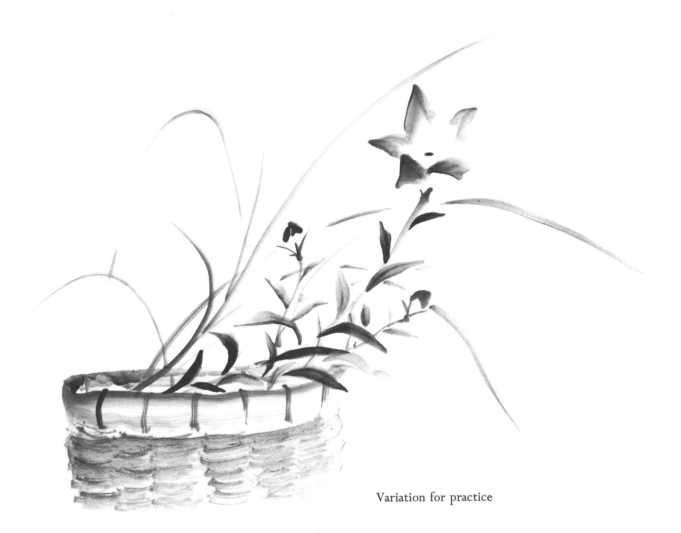

Variation for practice

SECTION
IV

In this section, painting explanations are shorter than in the previous two sections. The main reason for this is that there is really not much to tell you that you don't already know. All the strokes used here are those presented earlier or are slight variations of them. What remains for you now is practice, and by this stage you should be the best judge of how to proceed. It is also not too early to think about painting subjects that are not presented in this book. Surely in the area where you live there must be dozens, hundreds of varieties of trees, flowers, and plants that you can paint. Almost everyone who learns sumi-e remarks on how the art improves the perception of detail in nature. The artist learns to notice, for example, how leaves are arranged on a stem, how many petals a flower has, how young and old trees of the same species differ, how the mood and appearance of nature change with the location of the sun. If you have not been conscious of these kinds of things, why not go for a walk outside today to see how much in fact you have learned since you began painting? What you see may surprise you, and the excitement you feel can only encourage you to learn even more. Happily, there is no limit to what sumi-e can help you teach yourself.

FIVE
FLOWERS
AND
PLANTS

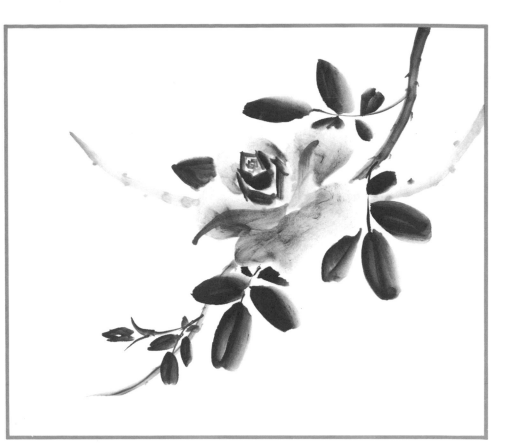

Rose

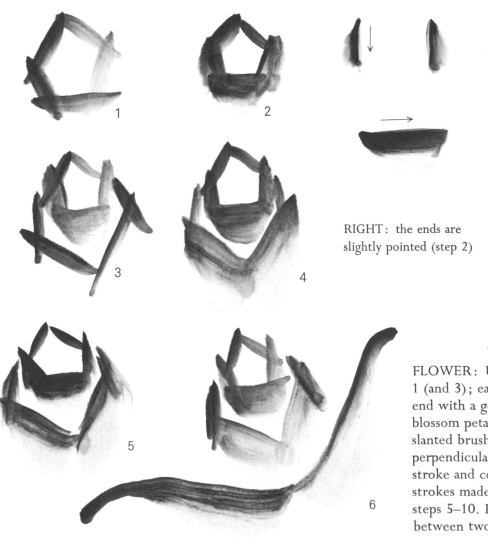

1

2

RIGHT: the ends are
slightly pointed (step 2)

WRONG

3

4

5

6

FLOWER: Use an upright brush for step
1 (and 3); each stroke should begin and
end with a gentle point, like a plum
blossom petal. For step 2 (and 4) use a
slanted brush; keep the brush handle
perpendicular to the direction of the
stroke and completely cover the lower
strokes made in step 1 (and 3). Paint
steps 5–10. Each petal emerges from
between two others.

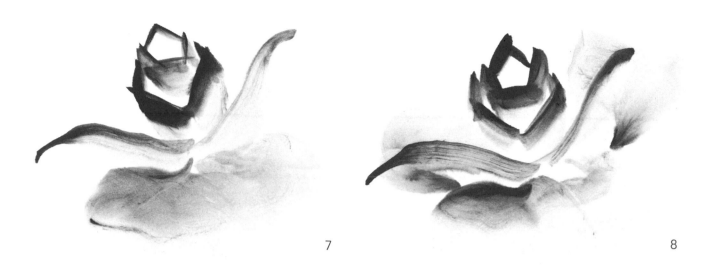

7

8

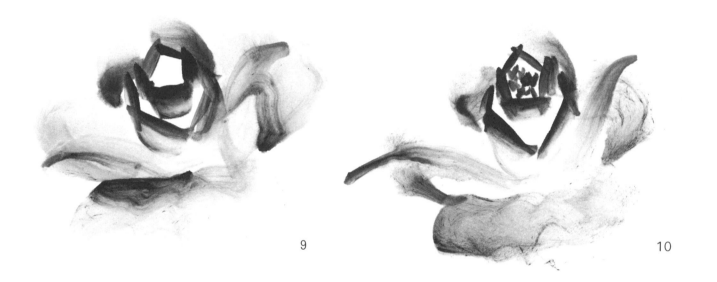

9

10

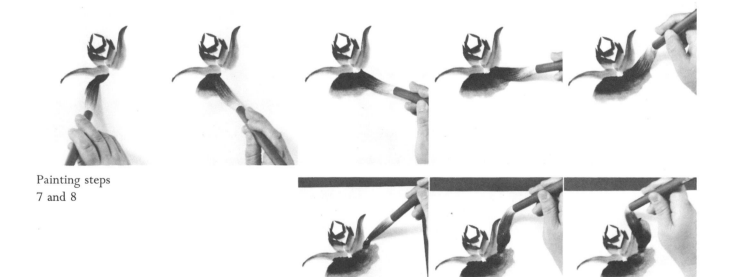

Painting steps
7 and 8

53

BRANCH: Use the technique for the pine branch, reducing the pressure as you paint in start-and-stop motions. For the thorns, place the bristles at the tip of an upright brush (medium-color sumi) exactly along the line of the branch. Then quickly lift and pull the brush away so that the stroke comes to a point.

LEAVES: Draw each stem with a strong line that starts from inside the branch and ends in a full stop. Stems should be staggered on the branch.

Use two strokes of an upright brush for each large leaf. For the first stroke, keep the tip of the brush on the outside edge of the leaf and give the stroke a slight, bulging curve. For the second stroke, keep the tip along the center line of the leaf; shape the outer edge with the base of the brush. For smaller leaves you can use just one stroke and medium-color sumi.

BUD: With an upright brush, paint strokes toward the base of the bud with increasing pressure. For the base, use wide flaring lines like those for the body of the morning glory flower.

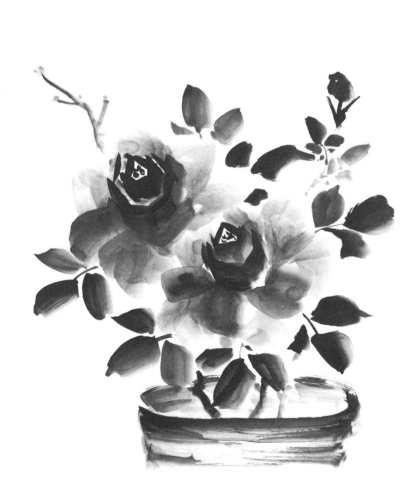

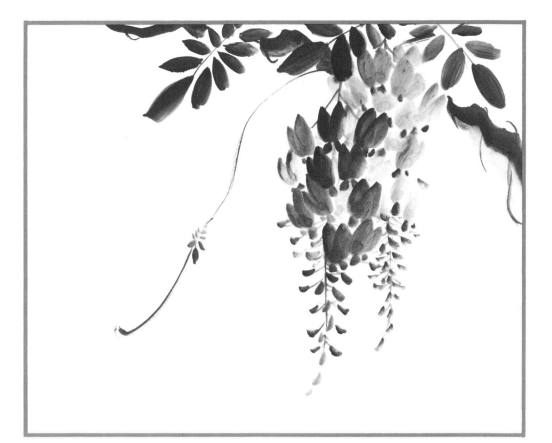

Wisteria

FLOWERS AND BUDS: Start in the center of the flower cluster. Paint each blossom with two strokes of an upright brush. For blossoms along the midline (stem), each stroke is of equal size. Blossoms to the right or left of the midline are angled toward the lower center of the cluster; their outside petals are smaller than those on the inside. Each bud is painted in one stroke, from top to bottom.

Place dots at the bottom of each blossom. Paint the stem as you did for the grape cluster. A slight curve at the bottom will make the entire cluster appear as if it is being gently blown by the wind.

TRUNK: Draw the trunk in sections. Start and stop the brush frequently and give the trunk large and vigorous angles.

LEAVES: Paint the stem. Paint the leaves with the technique you used for the rose leaves (two strokes for each leaf).

VINE: Paint the vine like the morning glory vine, pausing at the end. Add light-colored, young leaves.

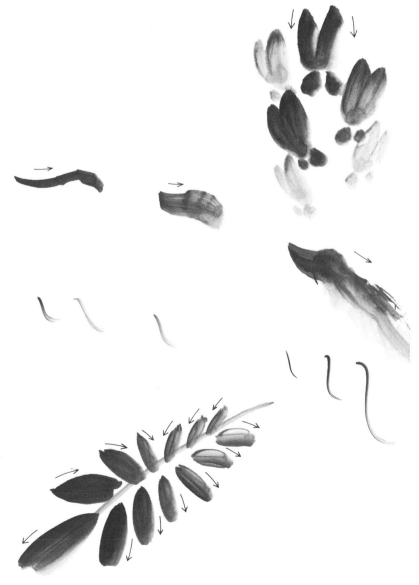

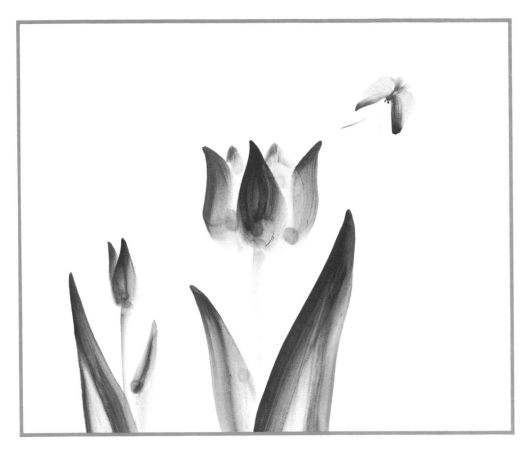

Tulip

FLOWER: Paint the center petal with two strokes of an upright brush. Start with the left half and increase pressure as you paint down; the tip of the brush should trail behind the base. At the bottom of the flower, swirl the base of the brush to the right along the paper; then remove the brush while the tip is still in the center of the stroke. This will give the bottom of the flower a nicely rounded edge. Repeat for the right half of the petal, this time swirling the base of the brush to the left.

Use one stroke of a slanted brush for the side petals. Keep the tip on the outside as you gradually apply pressure. Again, swirl the base of the brush at the bottom of the flower.

Each of the two petals in back is painted with two overlapping triangles.

STEM: Start with pressure inside the flower that bends the tip of the upright brush to the left; then remove pressure and paint a fairly thick line straight down.

Painting the first stroke of the center petal

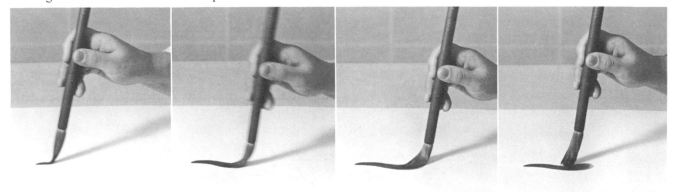

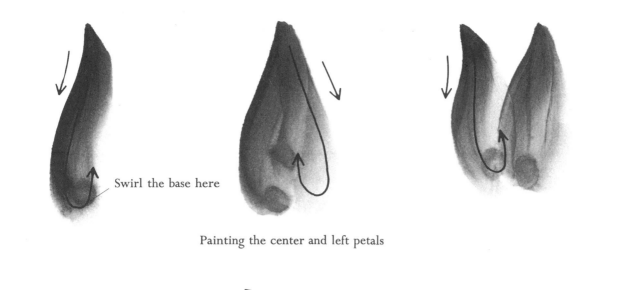

Swirl the base here

Painting the center and left petals

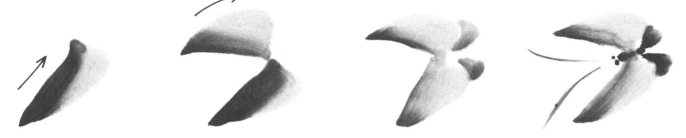

LEAVES: Use a technique like the one for the iris leaves. But use two strokes for each leaf. For each stroke, keep the tip of the upright brush on the outside. The leaf as a whole widens as it approaches the edge of the paper. The flower should appear to be standing between two leaves.

BUD: Use three strokes, two like those for the center petal of the flower and then one on the "shoulder" to show that the bud is beginning to open.

BUTTERFLY: Add a tiny butterfly to balance this composition. Use a slanted brush for each wing. Apply pressure and then lift the base of the brush, keeping the tip on the straight edge of the wing until the very end. Add two curving lines to show the back sections of the wings.

 Use one stroke of an upright brush for the head, then one for the body. Paint dots for the eyes. The antennae are two fine lines, not connected to the head.

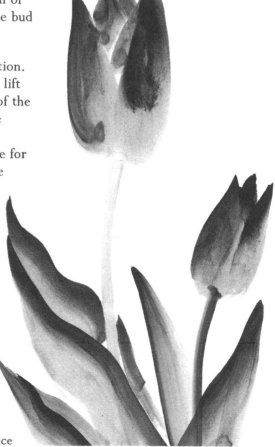

Variation for practice

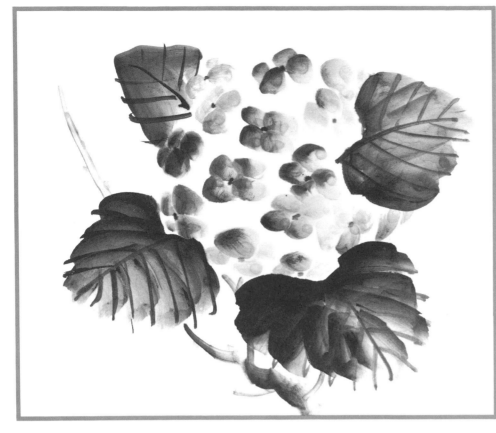

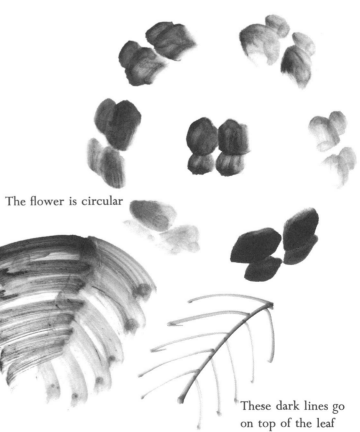

Hydrangea

FLOWER CLUSTER: Each flower in the cluster has four petals, and each petal is painted with the same kind of stroke. Use a slanted brush with the handle perpendicular to the direction of the stroke. Start with slight pressure; then increase the pressure as you draw the brush to the left. Gradually lift the base of the brush until only the tip remains on the paper. This is one stroke.

Add three more of these strokes—each painted at the same angle—to make a square group of four, or one flower. Strokes on the outside of the cluster will be smaller than strokes on the inside, and the entire cluster should be circular. Finally, place a dark dot in the center of each flower.

LEAVES: Make parallel, layered strokes with a slanted brush. Each stroke is like the one you used for the flower petal, but larger and elongated. Paint one half of the leaf at a time, always working from the center of the leaf to the outside and keeping the tip of the brush along the top edge of the stroke. As you move down the leaf, away from the flower, the strokes get shorter and lighter in color. With strong, dark sumi paint a center line and lines that angle out and extend beyond the edge of the leaf.

BRANCH: Use a start-and-stop motion with an upright brush.

RIGHT: the ends of each petal are rounded WRONG

The brush is held perpendicular to the direction of the stroke

The flower is circular

These dark lines go on top of the leaf

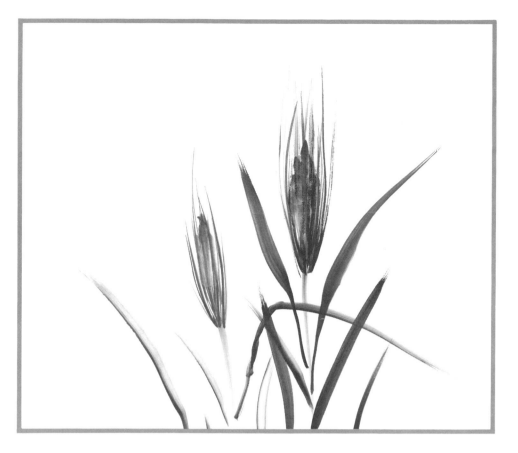

Wheat

EAR: Paint the entire ear with an upright brush and only one application of sumi. For each stroke, push down on the brush until the first third of the bristles contacts the paper. Then remove pressure and, barely lifting the tip from the paper, reposition the brush over the next area to be painted. Push down again. Proceed in this manner from the top of the ear down.

BEARD: Start below and at some distance from the ear. The space you leave will fill in as you paint. Paint strokes in the center first; these rise straight up. Then do the sides, gradually giving the strokes more and more of a curve so that they appear to enclose the ear.

STEM: Use an upright brush. Make the stem straight or give it a slight curve.

LEAVES: Use an upright brush. Work from the stem outward. For each leaf, apply pressure; then start lifting the brush. End with a very quick motion in the direction of the stroke. You may also reduce pressure on the brush as you paint and then reapply pressure in a different direction. This will make the leaf appear to be bent or twisted. Try using this technique the next time you paint the leaves of the Chinese orchid.

Paint each stroke
of the ear like this

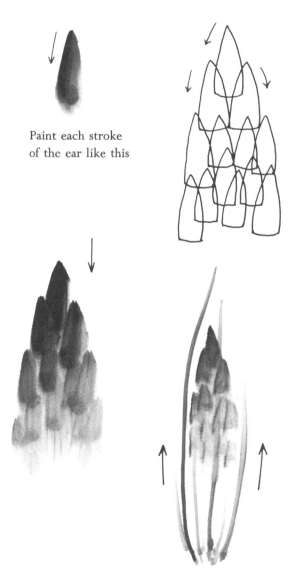

TREES

In this section are some hints and examples that will help you paint many different kinds of trees at different distances from the viewer. But the real key to a successful painting lies not in your knowing what technique to use but in your knowing how the tree you want to paint is "put together"—what patterns its leaves form, how the branches are arranged, whether the trunk divides near the base or near the top, and so on. Understanding *what* you are going to paint will often tell you *how* to paint it.

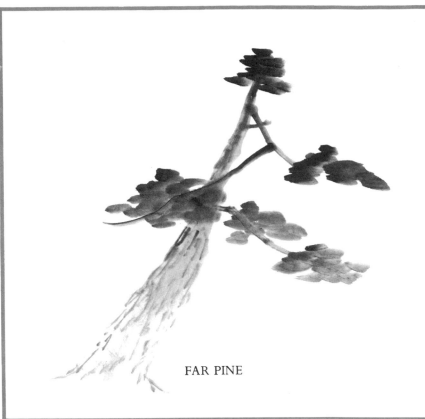

FAR PINE

Pine

FAR: Paint the trunk and branches with an upright brush in the order shown in the illustration. Use increasing pressure for the trunk (as you did for the grape vine) and decreasing pressure for the branches. Paint angular lines on the trunk with dark sumi to show the bark's rough texture.

Paint the needles with a slanted brush. For each stroke, place the tip of the brush on the paper, press the base down to the right, then lift the brush as you pull the tip through to the farthest point on the right painted by the base. Overlap the strokes to form triangular needle groups; keep each stroke parallel to the bottom edge of the paper as you paint. For very distant pine trees, see the facing page.

MIDDLE-DISTANCE: Use medium-color sumi to paint just the outlines of the trunk and branches. Add angular lines with dark sumi to show the bark's rough texture.

For the needles, use a zigzag motion (as you did for the bamboo branches) to paint several fan-shaped clusters. Then, with medium-color sumi, use a slanted-brush stroke to add background to each needle group until it becomes triangular in shape.

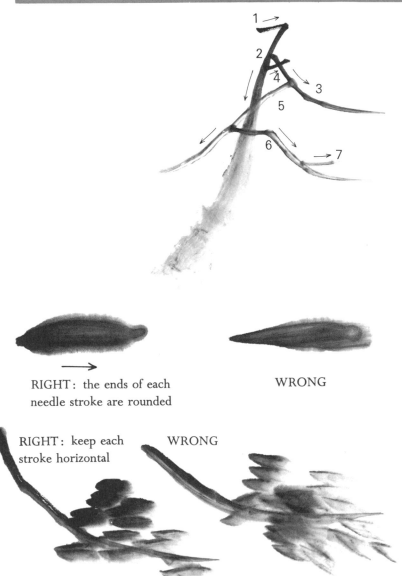

RIGHT: the ends of each needle stroke are rounded

WRONG

RIGHT: keep each stroke horizontal

WRONG

60

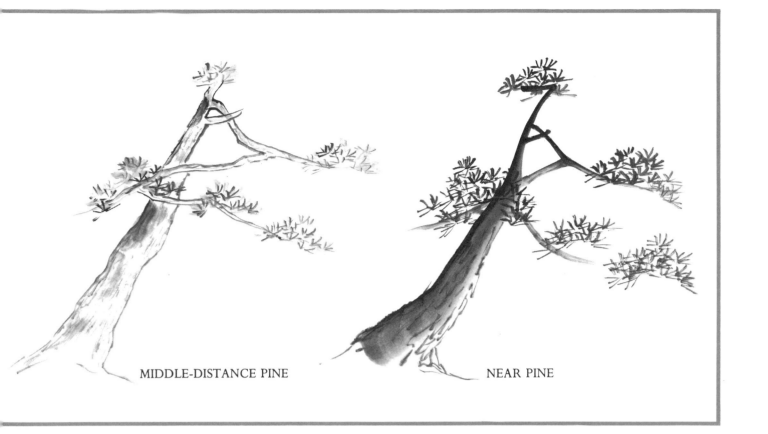

MIDDLE-DISTANCE PINE

NEAR PINE

Finally, fill in the trunk with medium-color sumi. Fill in the branches in similar fashion.

NEAR: The trunk and branches are painted just like those for the far pine.

For the needles, use dark sumi and overlap needle clusters to form large triangular groups.

DISTANT: These are pines as would be painted on a far-away mountain. They are greatly abridged, but notice that the needles are suggested by overlapping strokes that are smaller than those used for the far pine but painted exactly the same as them—horizontally. Consistency of technique is what makes the pine recognizable, no matter what distance it is from the viewer.

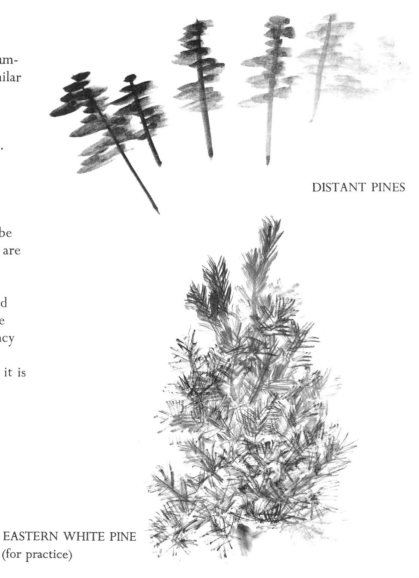

DISTANT PINES

EASTERN WHITE PINE
(for practice)

61

Cedar

FAR, MIDDLE-DISTANCE: Paint the trunk from the top down with a single stroke of an upright brush. Add the branches; pause with the brush at irregular intervals for long branches and let each branch come to a point.

At the top of the tree use an upright brush to add three strokes like those used for the ear of wheat, but longer and narrower. Then overlap similar strokes for the rest of the needles; make sure the base of each of these strokes is facing the lower center of the tree.

NEAR: Draw only the outline of the trunk. Add the branches as explained above. Paint the needles with straight lines thickening at the base, making sure each points to the center of the tree. Now, with light sumi, add several thin lines to fill out the trunk from the top down. Use medium-color sumi to paint overlapping strokes as background for the needles. Paint the needles thicker and leave out the background strokes for a cedar in the foreground.

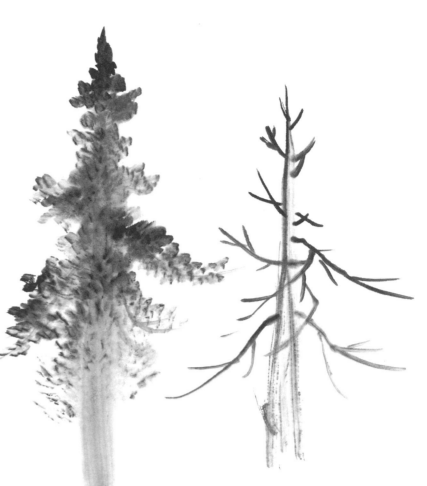

FAR, MIDDLE-DISTANCE CEDAR

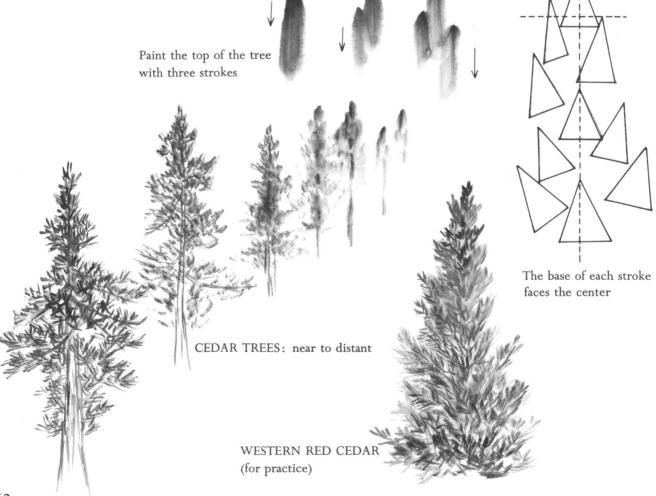

Paint the top of the tree with three strokes

The base of each stroke faces the center

CEDAR TREES: near to distant

WESTERN RED CEDAR (for practice)

62

Willow

MIDDLE-DISTANCE, NEAR: Use an upright brush for the trunk (increasing pressure) and branches (decreasing pressure). Each drooping branch moves up in a slight arc before it comes down.

The weeping willow and black willow differ in the arrangement of their leaves on the branch; each separate leaf, however, is painted exactly the same. Use a stroke like that for the plum blossom petal, adding pressure with an upright brush to the center of the leaf. Give the leaf a slight curve. For the weeping willow, arrange these strokes almost parallel to each other. For the black willow, arrange the leaves in clusters of four or five, with each leaf pointing to the center of the cluster.

How many leaves you add and whether or not you use background shading (as you did with the pine and cedar) will determine whether the willow is near to or at a slight distance from the viewer.

FAR, DISTANT: Paint the trunk but leave out the branches. For the leaves, use the same kind of stroke you used for each leaf above but much larger (about two-thirds the length of the tree itself).

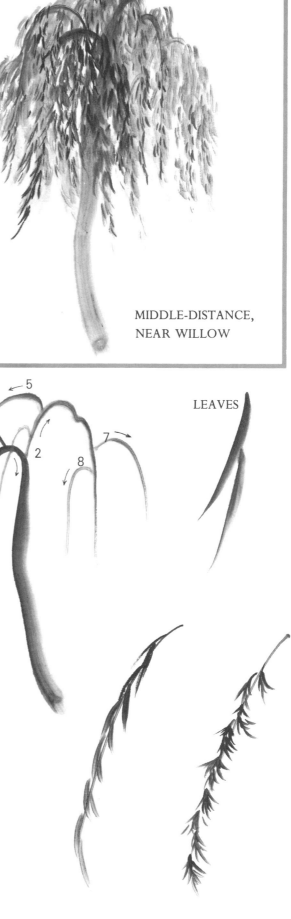

MIDDLE-DISTANCE,
NEAR WILLOW

LEAVES

FAR, DISTANT WILLOWS

WEEPING WILLOW
BRANCH

BLACK WILLOW
BRANCH

63

Some other kinds of trees

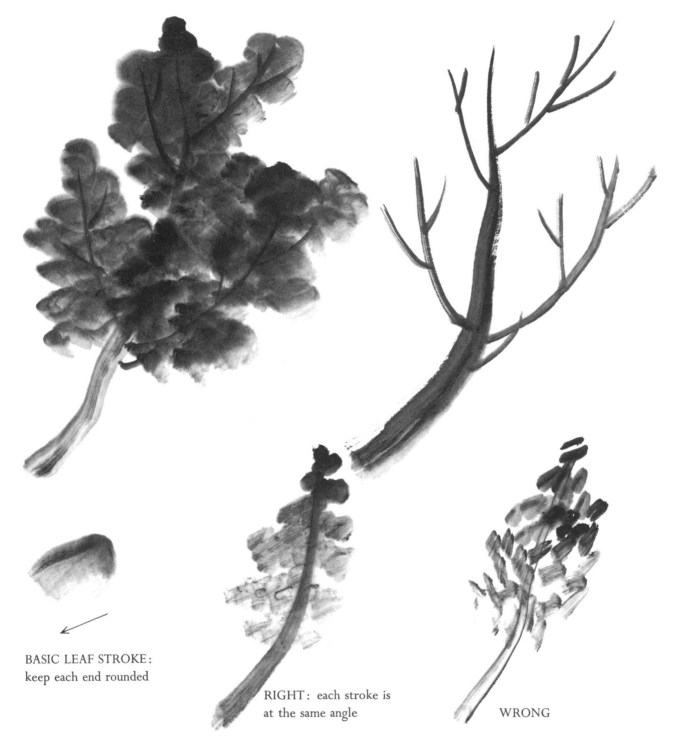

BASIC LEAF STROKE:
keep each end rounded

RIGHT: each stroke is
at the same angle

WRONG

BASIC TECHNIQUE: Here is a technique that
will work for many kinds of deciduous trees. Paint
the trunk and branches with an upright brush.
Use a slanted brush for the leaves, with the handle
perpendicular to the direction of the stroke. Paint
the leaves to the left; apply and then reduce
pressure as you did for the hydrangea petal. The
ends of each stroke are rounded. Paint each stroke
at the same angle, overlapping the strokes about
the branches until the tree is complete.

DISTANCE AND VARIETY: Using the basic
technique above and adjusting the wetness of the
brush, the shape of the trunk, or the size of the
strokes for the leaves, or all three, you can vary
the kind of tree you paint and the distance it
appears to be from the viewer. But no matter what
kind of tree you paint, make sure all the leaves
lie on the branches at the same angle. Four different
examples are provided.

Samples of other trees and tree elements are
given on pages 66–67. You have already learned all
the strokes you need for these subjects. Now, try
to paint them.

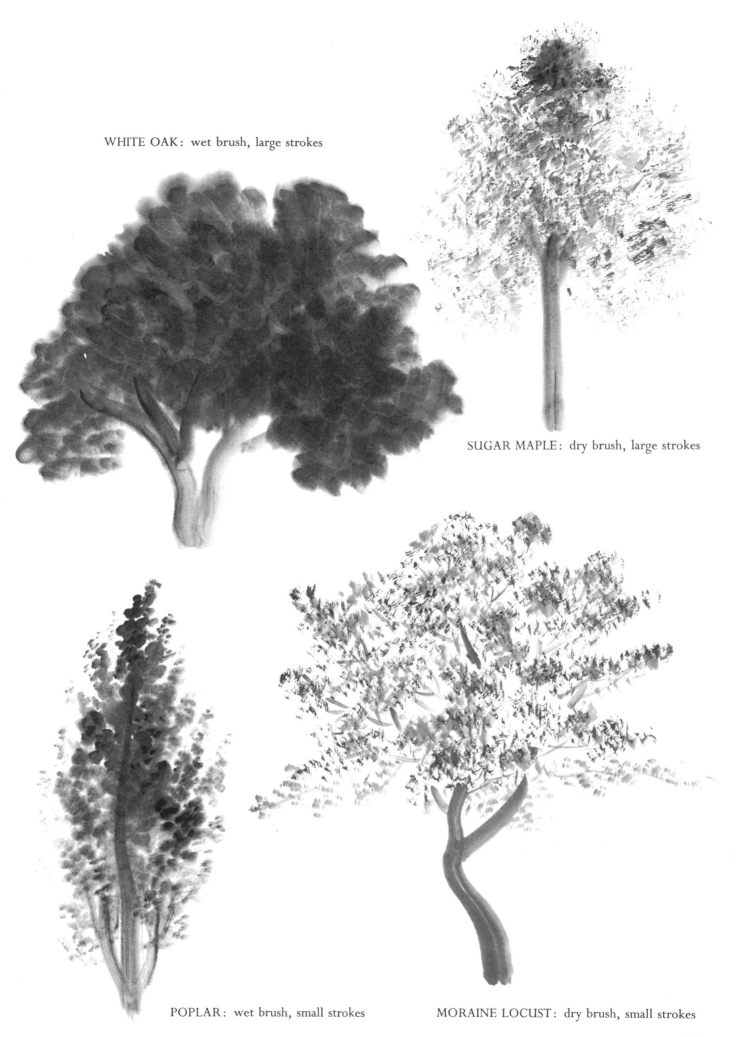

WHITE OAK: wet brush, large strokes

SUGAR MAPLE: dry brush, large strokes

POPLAR: wet brush, small strokes

MORAINE LOCUST: dry brush, small strokes

65

BRANCH PATTERNS

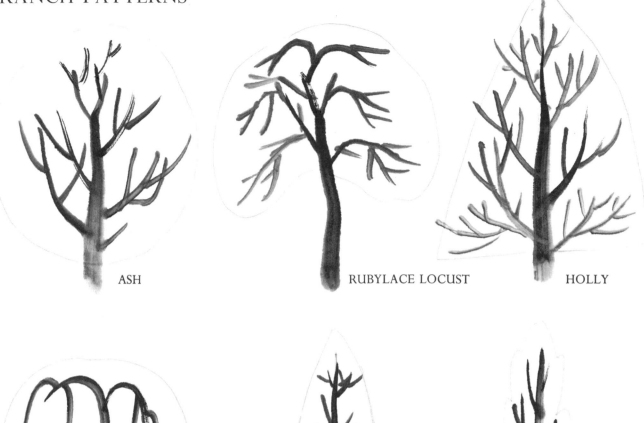

ASH

RUBYLACE LOCUST

HOLLY

WEEPING WILLOW

CEDAR

POPLAR

TREE FORMS

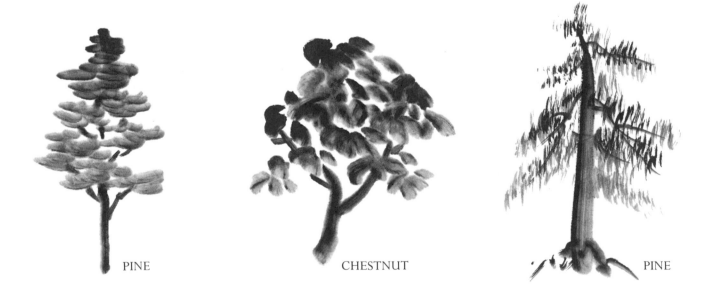

PINE

CHESTNUT

PINE

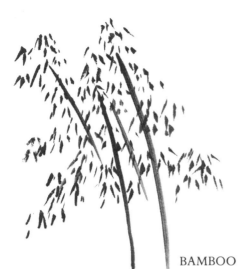

BAMBOO

OAK

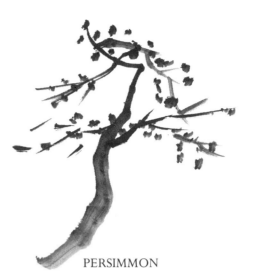

PERSIMMON

LEAF FORMS

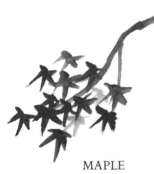

MAPLE

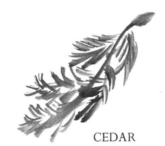

CEDAR

HOLLY

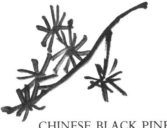

CHINESE BLACK PINE

PINE

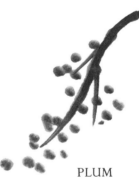

PLUM

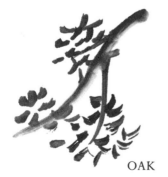

OAK

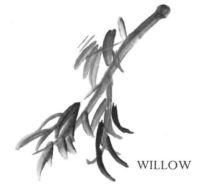

WILLOW

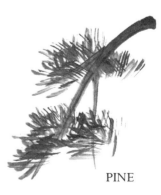

PINE

LANDSCAPE ELEMENTS
Ground

Use a wet, slanted brush. Lay the tip on the paper, press the base down, then, as you lift up, draw the tip through to the edge of the line painted by the base. Overlap these strokes, keeping each one horizontal.

Add small bamboo trees as shown in the illustration to make a simple composition.

Rocks

Draw the rock in one or two strokes with a slanted brush. Use a start-and-stop motion to change the direction of the stroke. Add water by painting a hooked line around the corner of the rock. Then pull the brush smoothly to the right to show the flow of the current. Make parallel, swelling lines.

Crags and cliffs

Use the technique for the rocks when painting a rugged crag or cliff, changing the shape of the stroke, of course. At the base of the cliff, pull the brush to the right and then push it upward along the paper so that the bottom of the cliff, where it rises from the water, is a straight line. Paint small, distant pines on the cliff. Add water with lines in dark sumi to suggest the flow of the current.

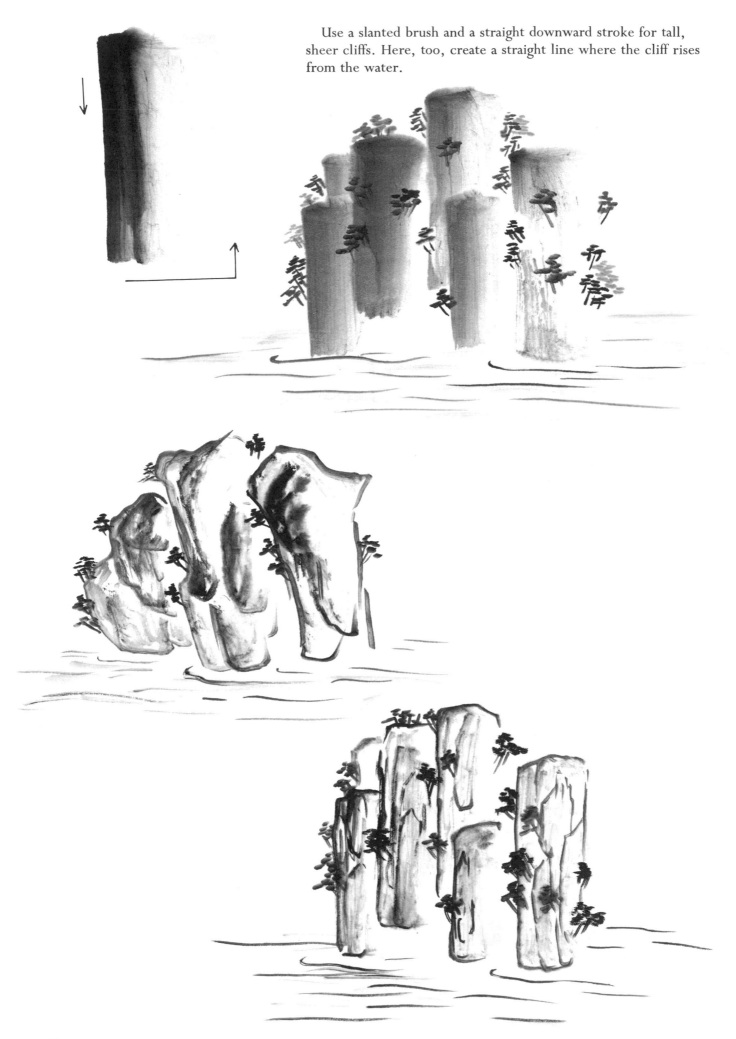

Use a slanted brush and a straight downward stroke for tall, sheer cliffs. Here, too, create a straight line where the cliff rises from the water.

Hills and mountains

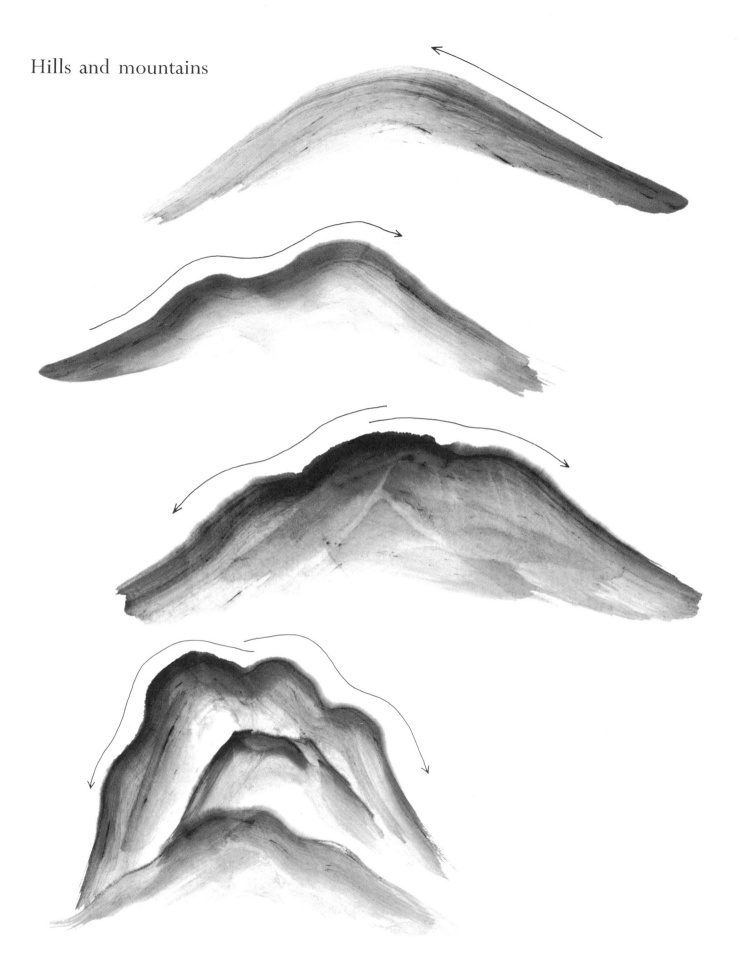

Paint hills and mountains with a slanted brush. Use one stroke or two as appropriate. Apply the most pressure at the top of the mountain or vary the pressure as you paint to create several peaks. Practice the examples given here.

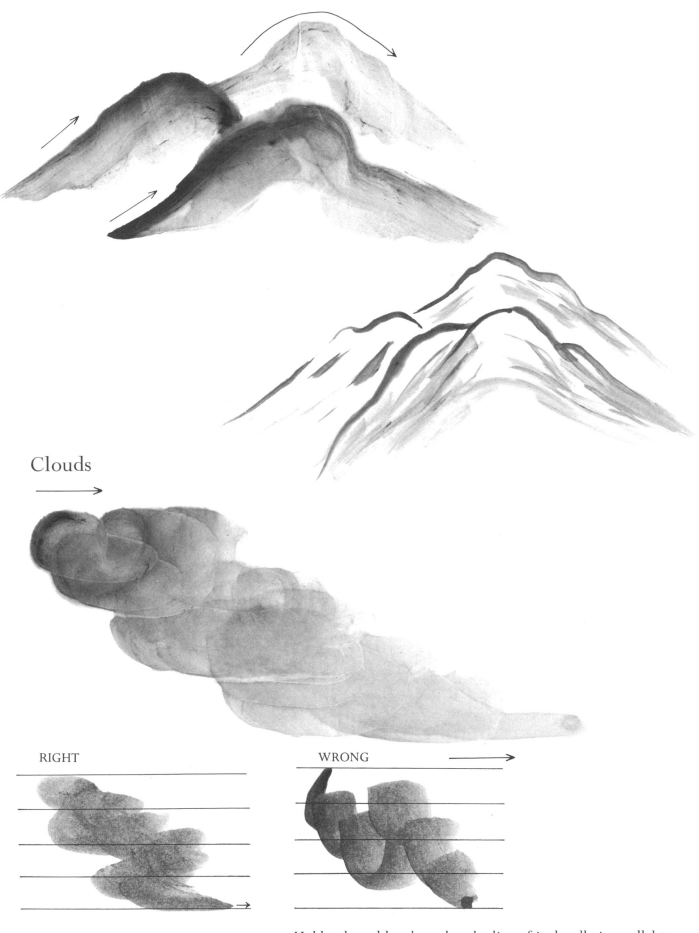

Clouds

RIGHT

WRONG

Hold a slanted brush so that the line of its handle is parallel to the bottom edge of the paper. Without changing the orientation of the brush, paint in continuous circular motions up and down to fit the space you have. Keep the lower edge of each "cloud puff" horizontal. End in a straight line that trails off to the right.

Water

SWELLS: With strokes like those for the plum blossom petals, paint long horizontal lines to represent the waves on the surface of the sea. Alternate the peaks and troughs. Leave the caps of the waves white and fill in the rest of the waves with light sumi. Draw a jagged edge in dark sumi below the cap. Then draw gradually sloping parallel lines to suggest the movement of the sea.

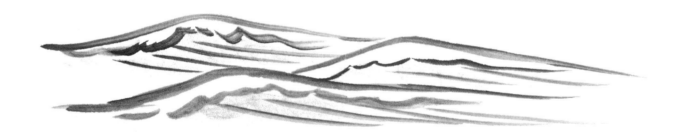

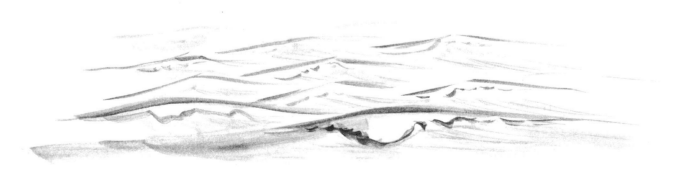

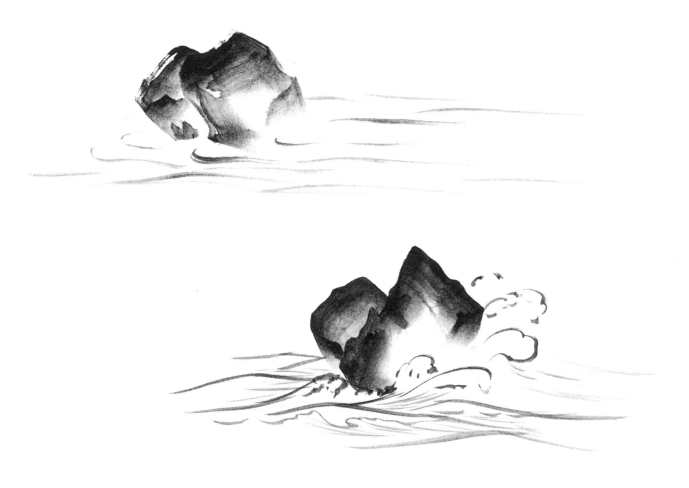

BREAKERS: Use the same stroke you used for the plum blossom petals to paint the frothy caps. Leave the caps white and add a little light sumi for shading. Then draw parallel lines in the direction of the waves below.

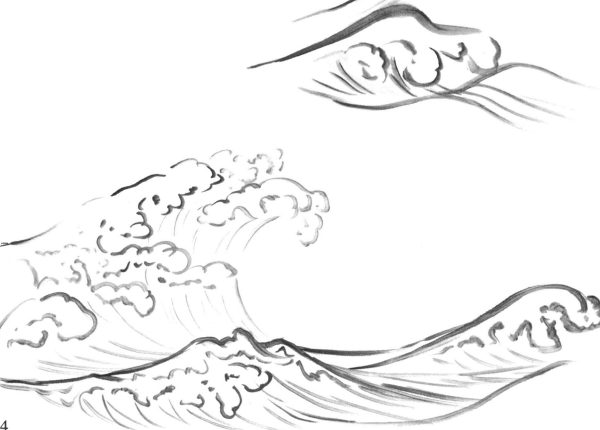

WATERFALL: Paint the sides of the falls with the same technique that you used for the crags. Paint the falling water with a few strong but thin strokes from the top down. Use strokes like those for the plum blossom petals to paint the splashy froth at the base of the falls. Add lines to show the water running downstream from right to left.

WHIRLPOOL: With an upright brush, paint strokes using the same technique as for the plum blossom petals. Keep the center of the whirlpool dark to accentuate the swirling motion of the water.

75

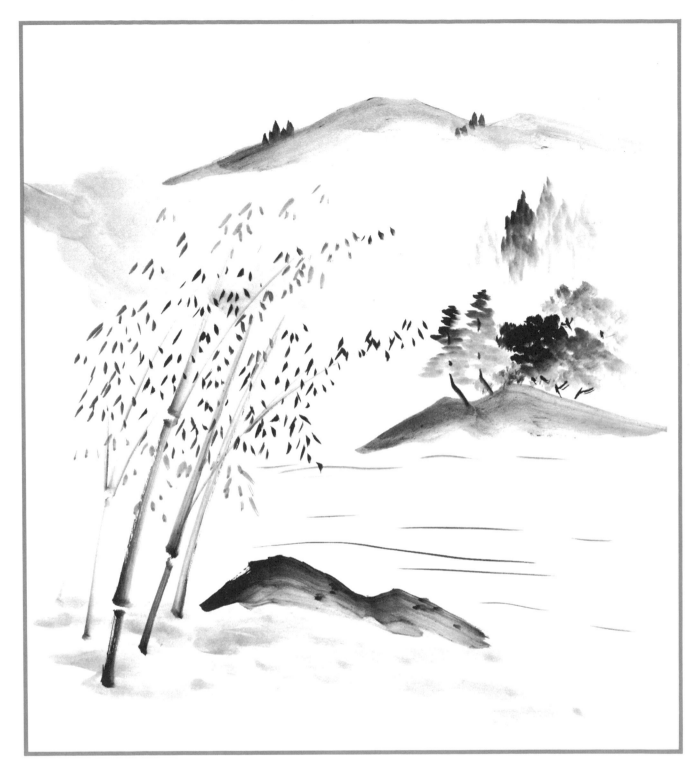

COMPOSITION

Now try to combine some of the scenery elements and trees into a complete landscape. Landscapes in sumi-e generally are divided into three sections: near, middle, and far. Always start with the foreground and work back "into" the painting, gradually using lighter sumi and less detail. The foreground is the focus of a sumi-e composition, and the background, increasingly misty and indistinct, suggests to the viewer a world that is open-ended, infinite, and full of possibilities. You should therefore control your impulse to fill in detail and aim instead for overall balance in the elements. Because the closest objects are painted first, objects behind the foreground can never be overwhelmingly dark. Thus, the sumi shades that you select for the foreground will to some extent determine the tones that you use for all the other elements in the composition.

Near elements

1. Paint the bamboo. Add only a few leaves with dark sumi and paint the rest of the leaves with medium-color sumi in the back. Note that all parts of the bamboo, no matter how small, are painted with the same techniques used for the large bamboo in the beginning of this book. You need not paint the joints.
2. Add the ground.
3. Paint boulders. Use dark sumi to add dots that suggest moss.

Middle-distance elements

1. Paint light-colored crags.
2. Place pines on the crags. Make sure that each stroke for the needles is applied horizontally.
3. Add deciduous trees behind the pines. Paint each stroke for the leaves with the brush held at the same angle.
4. Paint tall cedars. Bring the top of each tree to a point with three overlapping strokes; the remaining strokes for the leaves should all slant toward the lower center of the tree. Leave spaces between tree groups and vary the sumi shades to indicate mist and distance.

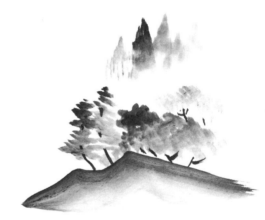

Far elements

1. Paint the mountain in two strokes.
2. Paint cedar trees on the mountain with single strokes of an upright brush.
3. Add clouds to suggest great distance between the middle and far sections of the composition.

To complete this landscape, add appropriate, medium-color lines that indicate the surface of the water.

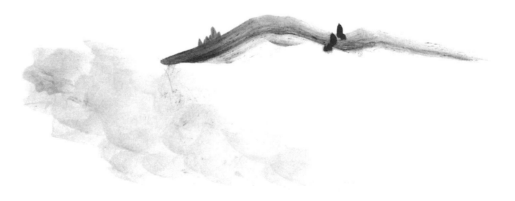

Here are two more compositions for you to practice

LANDSCAPE

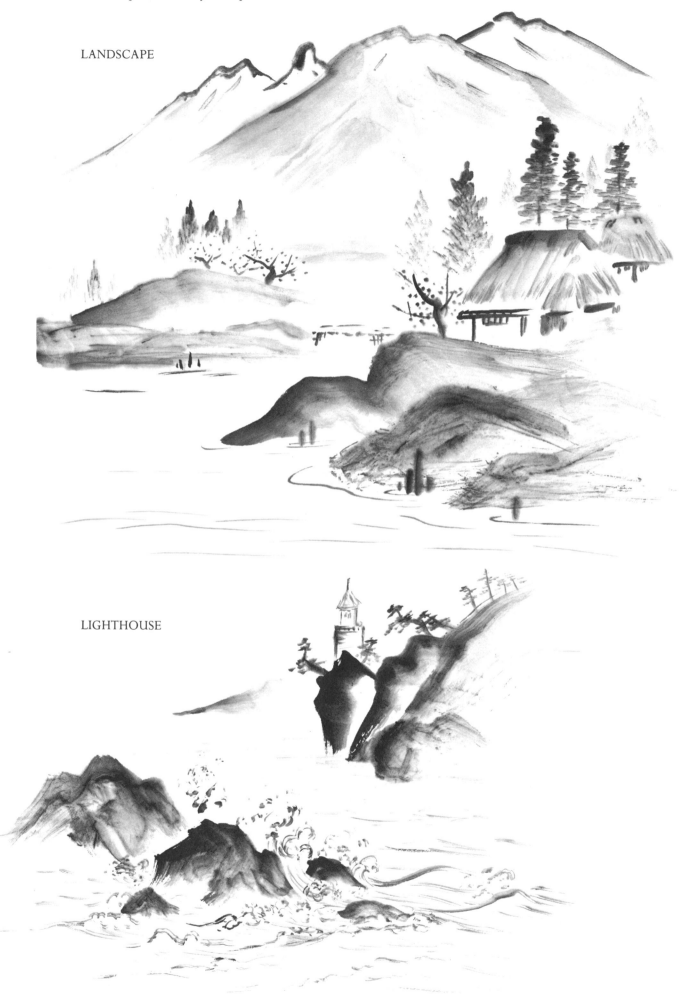

LIGHTHOUSE

SECTION

V

Sumi-e is many things to many people. As was mentioned in the Introduction, the men who perfected the art of monochrome painting in Japan (after it was introduced from China some 500 years ago) were Zen priests. Their earliest works naturally used Buddhist themes. They intentionally rejected color in their paintings for they believed that underlying the chaotic, visible world were simple truths that could best be expressed by equally simple but boldly painted lines on a plain background. Sumi-e has since become a popular art, but there are still many sumi-e artists who treat their work ceremoniously and as a spiritual exercise. Though several aspects of this approach to sumi-e have been mentioned here, this book has been based more on the principle that sumi-e can be an art just for you, no matter where you are and no matter what your goal. If there is meaning in sumi-e you will find it in a way that is just right for you. The important thing is that you relax when you paint and let your brush express what you feel. The sample paintings that follow are provided to give you additional material for practice and to show you the many different ways in which sumi-e techniques can be used. The paintings are grouped by subject and can be practiced in any order you choose.

FRUITS AND VEGETABLES

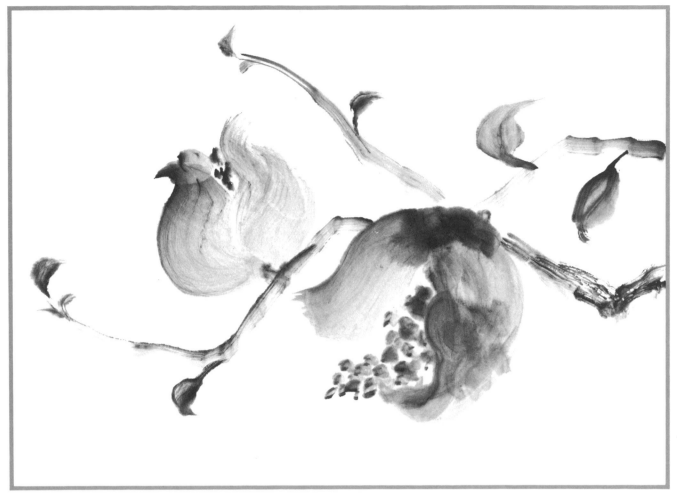

Pomegranate

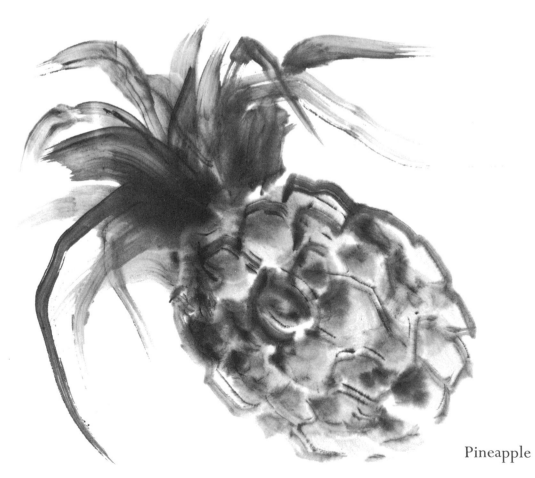

Pineapple

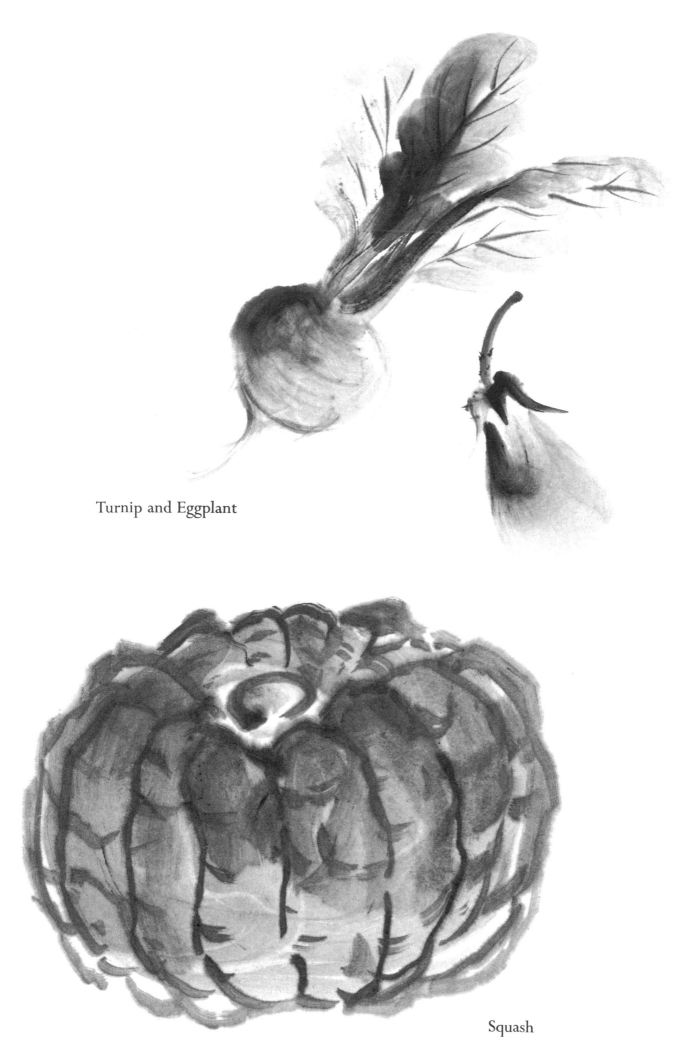

Turnip and Eggplant

Squash

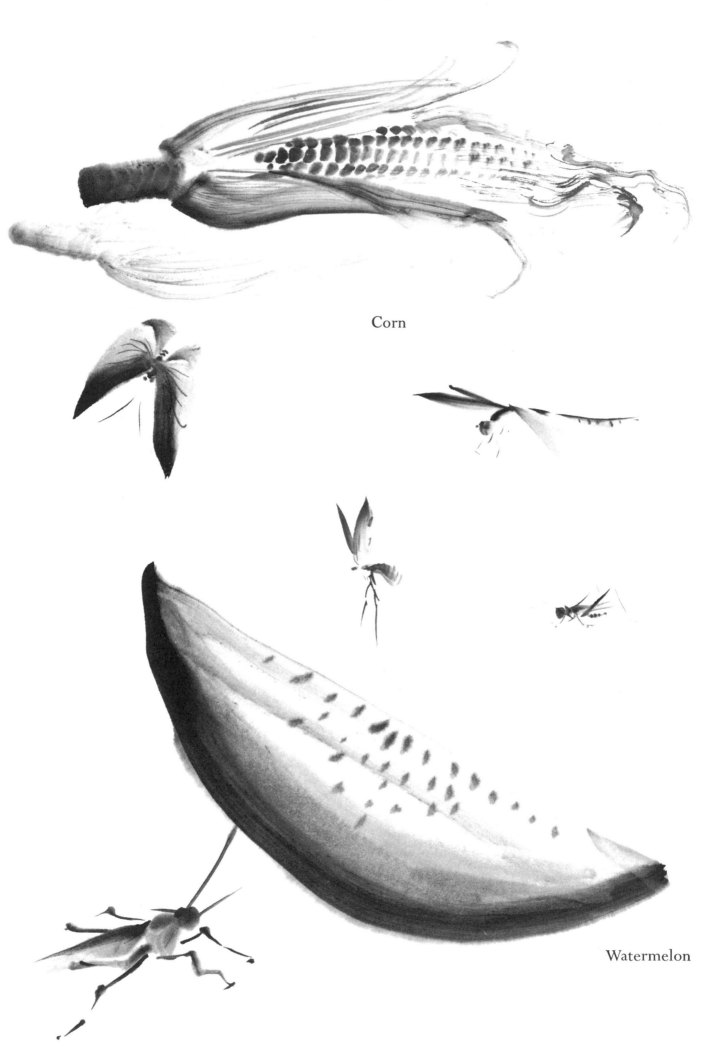

Corn

Watermelon

FISH, ANIMALS, AND BIRDS

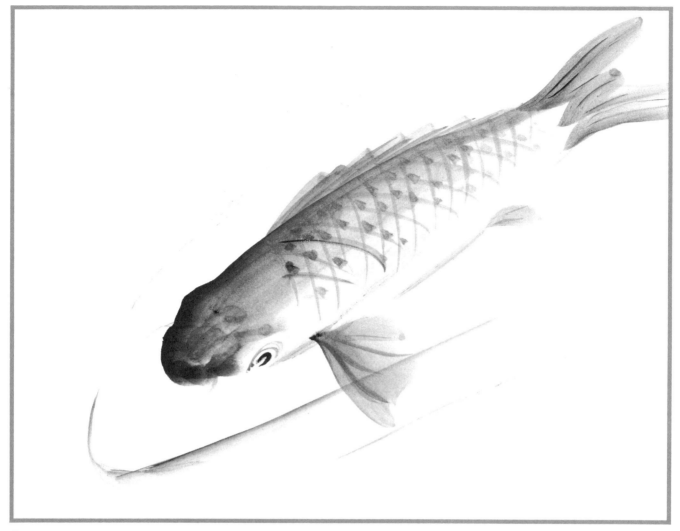

Carp

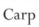

Goldfish

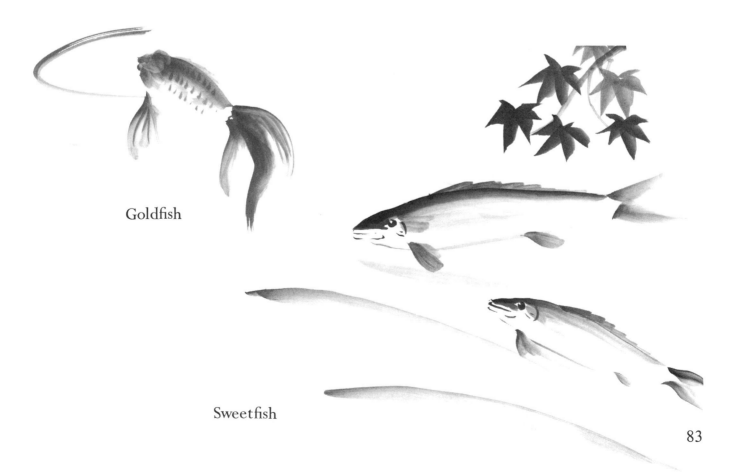

Sweetfish

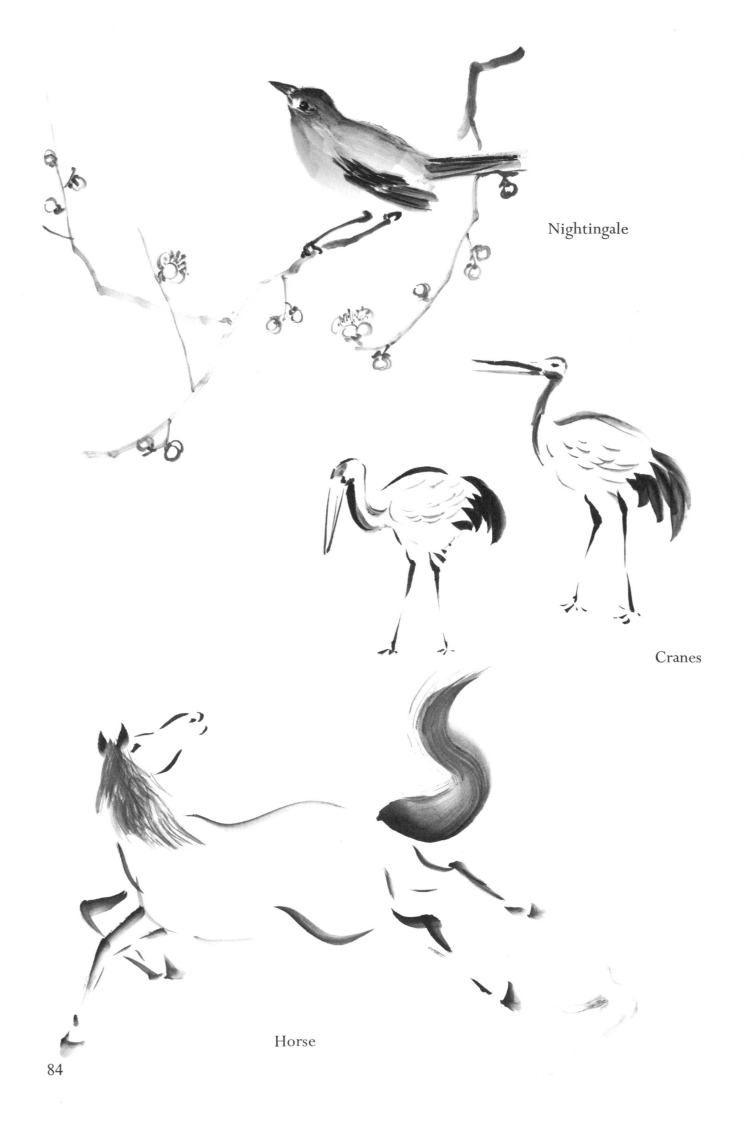

Nightingale

Cranes

Horse

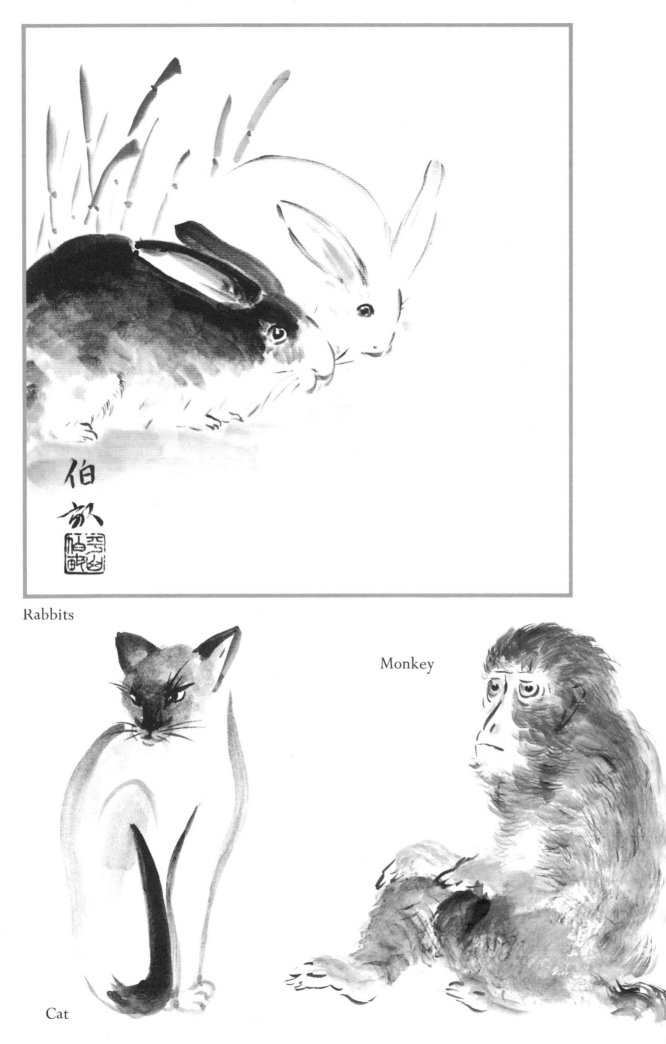

Rabbits

Cat

Monkey

PEOPLE

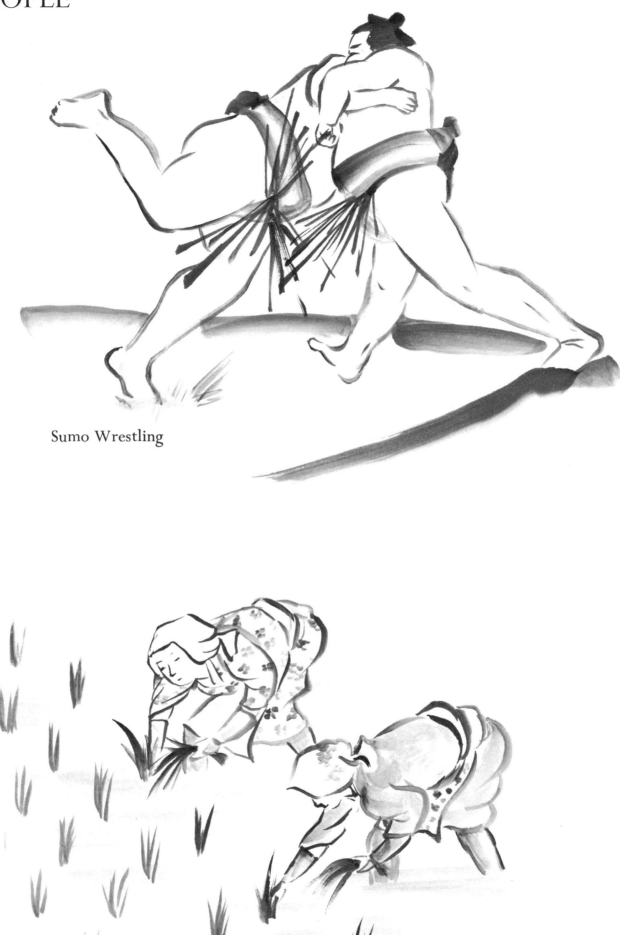

Sumo Wrestling

In a Rice Field

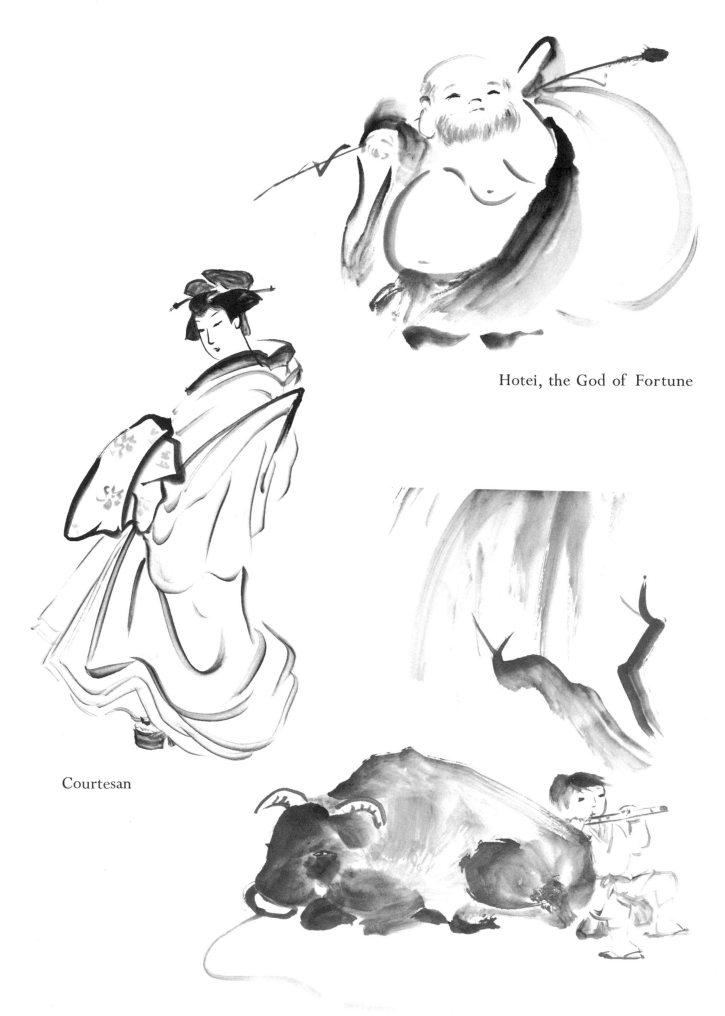

Hotei, the God of Fortune

Courtesan

The Ox and the Boy

FLOWERS, PLANTS, AND TREES

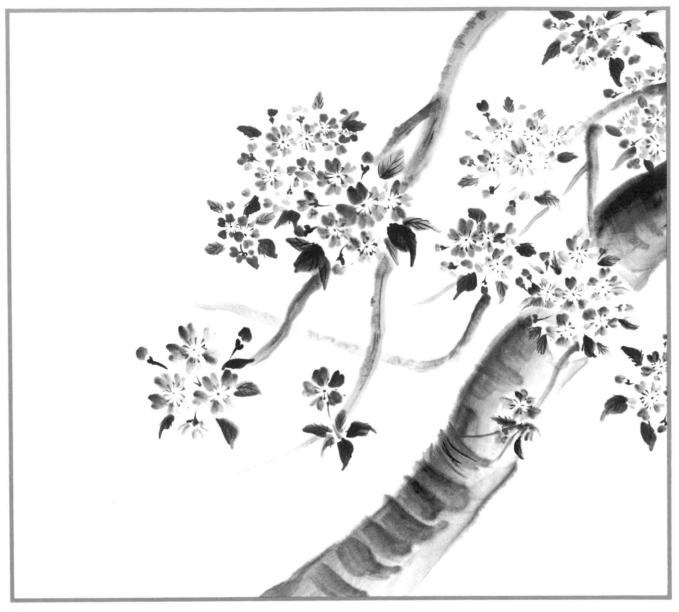

Cherry

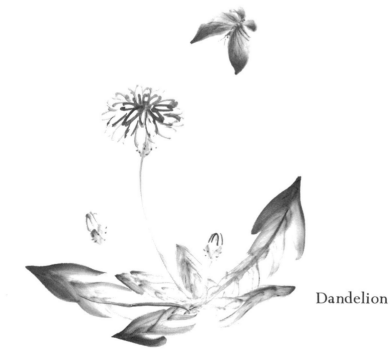

Dandelion

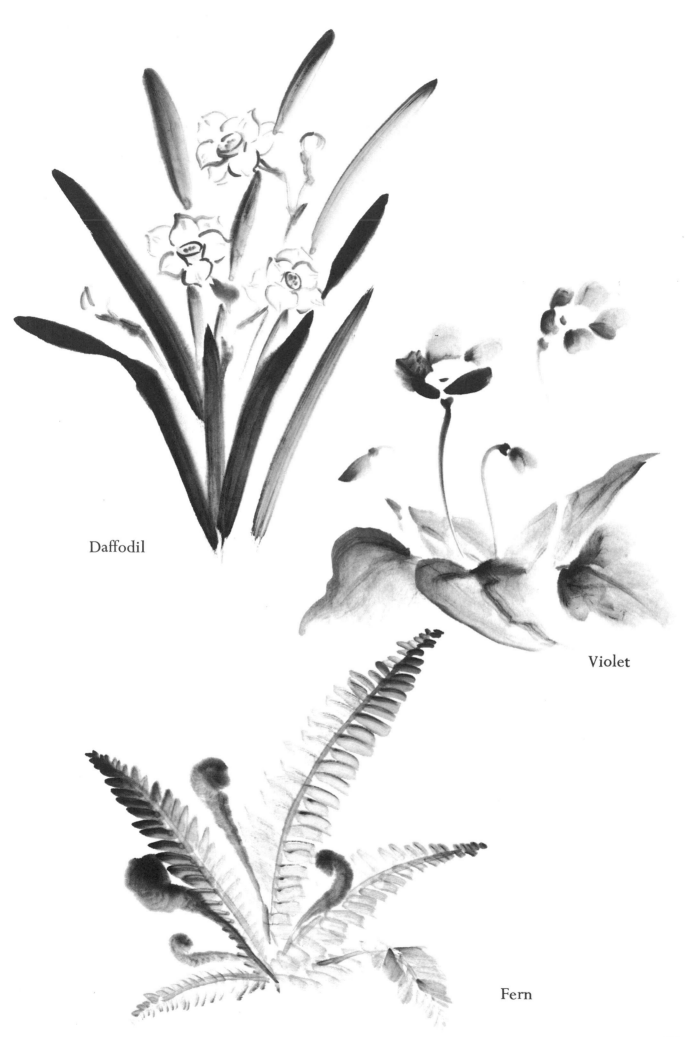

Daffodil

Violet

Fern

89

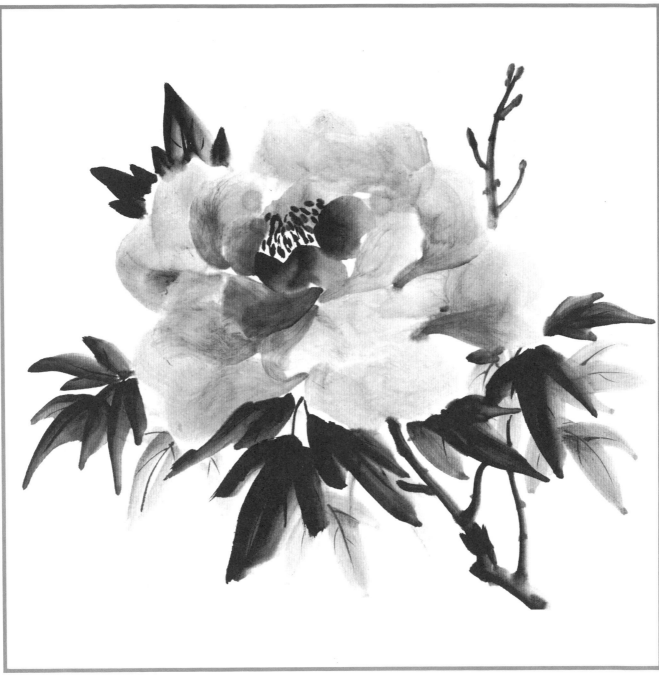

Peony

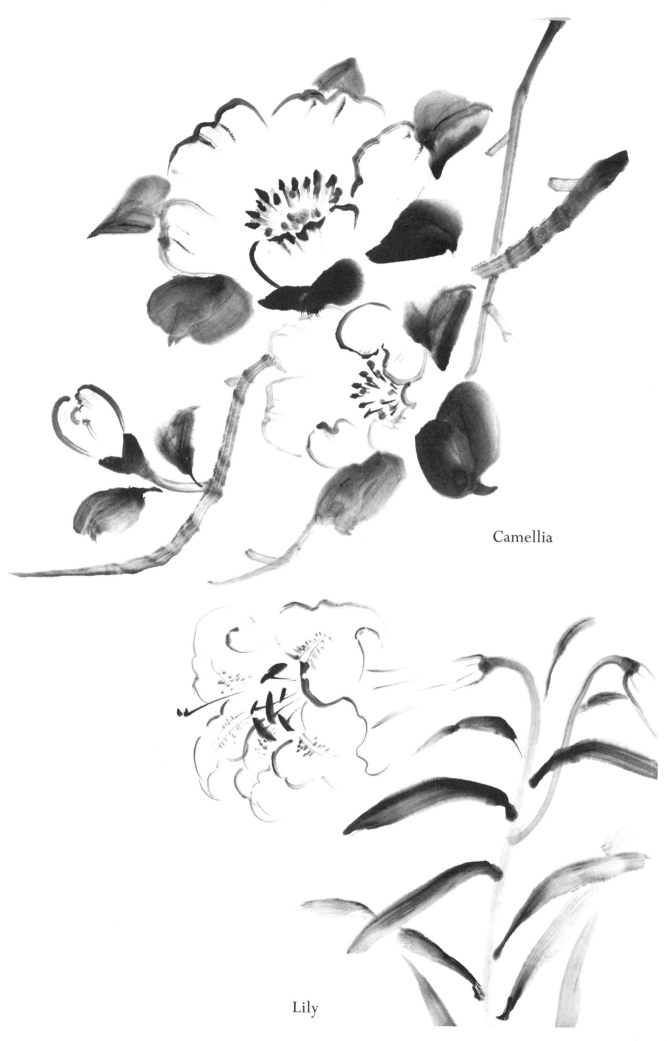

Camellia

Lily

91

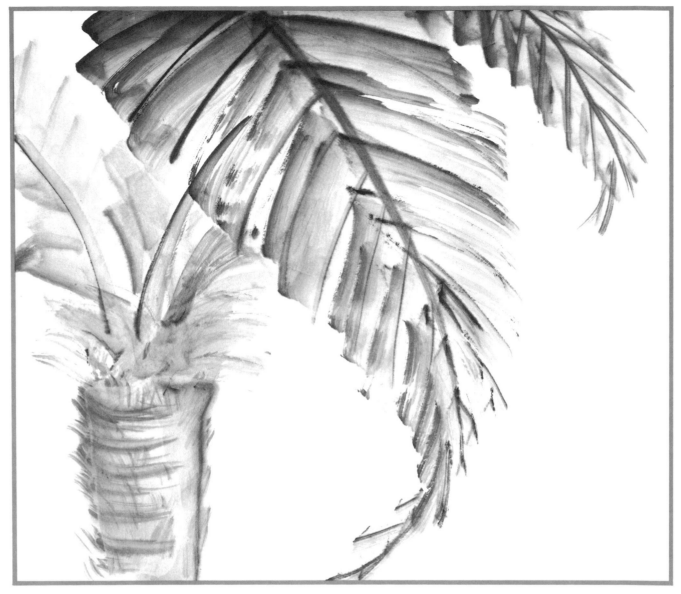

Palm

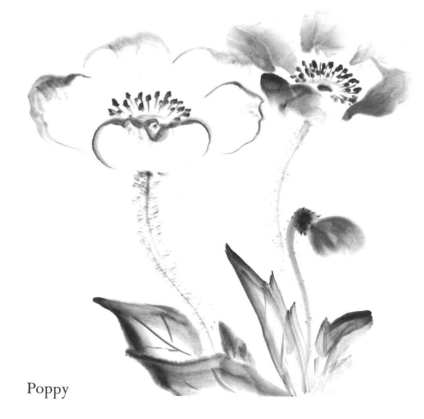

Poppy

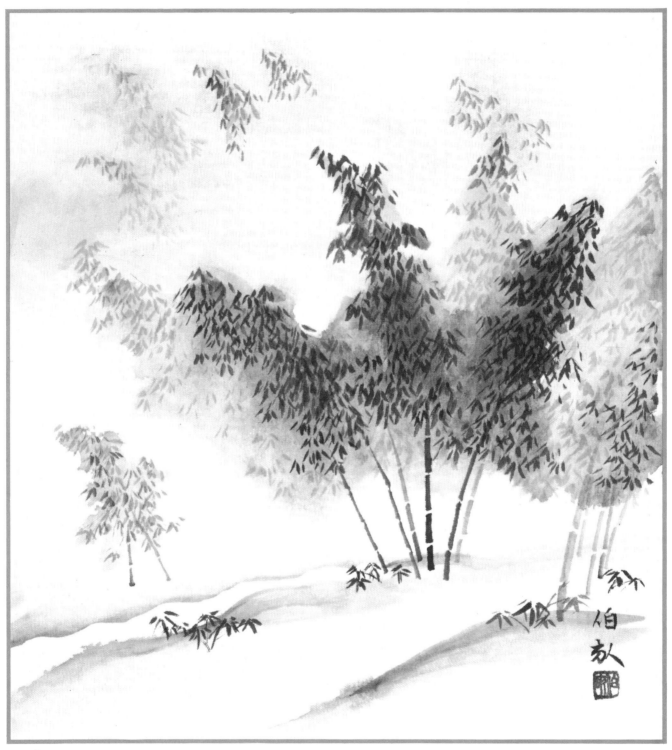

Bamboo

APPENDIX: PRACTICAL SUMI-E

You can use sumi-e techniques on many different surfaces to make attractive furnishings for your home or unusual gifts for your family and friends. Some examples of what you can do are given here. Sumi painted on cloth will not run when washed, but to prevent bleeding and spreading as you paint (a problem especially with thin fabrics), add a small amount of CMC (a powdered fixing agent) to the water in which you dip your brush. Let the water stand for an hour or so to make sure the CMC is thoroughly dissolved. For difficult fabrics, add CMC directly to the water in the well of the suzuri. Pin fabric to a table to prevent it from moving as you paint.

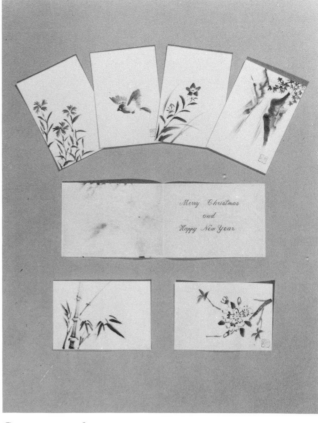

Greeting cards

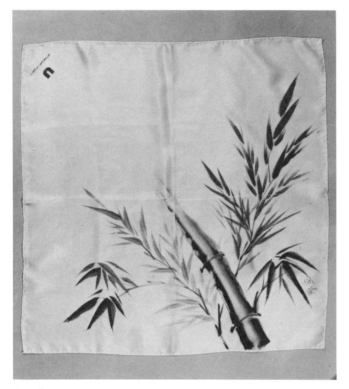

Scarf

Noren curtain

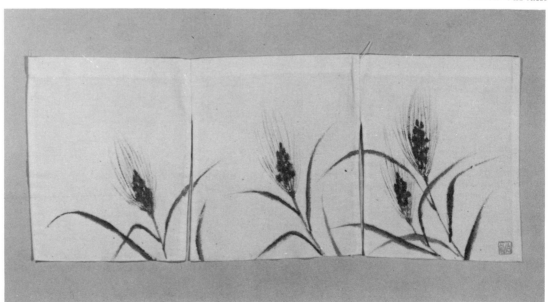

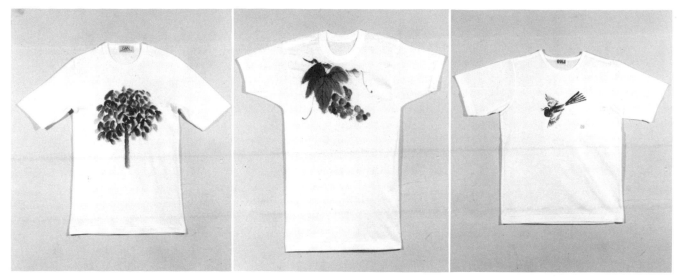

T-shirts

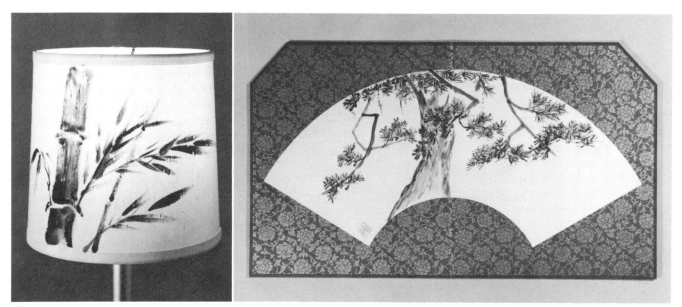

Lampshade Miniature screen

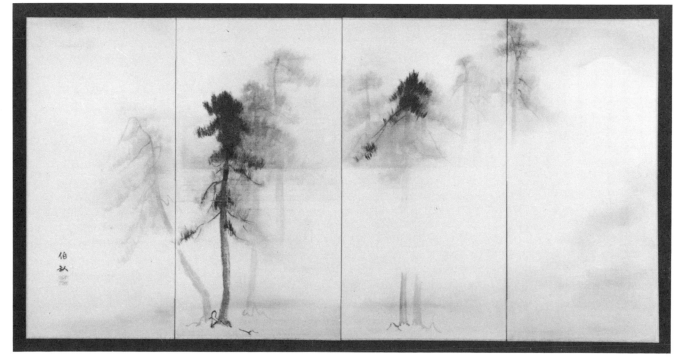

Large screen

95

Hakuho Hirayama, a graduate of Japanese
Women's University in Tokyo, has worked in sumi-e
since early childhood and has taught the art to the
foreign community in Tokyo for over thirty years.
Formerly the student of well-known sumi-e artists
Taisei Mizukami and Keiho Kusuhara, Mrs. Hirayama
conducts regular classes at the Tokyo American Club
and has also taught and performed demonstrations of
sumi-e techniques in Europe, Southeast Asia, and
the United States.

The sumi-e materials that you need for working with
this book can be purchased at almost any store that
deals in Oriental goods. If no such store is in your
area you can order supplies by mail from the
following firms:

Hakubundo, Inc.
100 North Beretania Street
Honolulu, Hawaii 96827
(808) 521–3805

Mikado
Japanese Cultural and Trade Center
1737 Post Street
San Francisco, California 94115
(415) 922–9450

Zen Oriental Books
521 Fifth Avenue
New York, New York 10017
(212) 697–0840